REDUCTIONISM

IN ART AND

BRAIN SCIENCE

ALSO BY ERIC R. KANDEL

*Cellular Basis of Behavior: An Introduction
to Behavioral Neurobiology*

Principles of Neural Science

Psychiatry, Psychoanalysis, and the New Biology of Mind

Memory: From Mind to Molecules

In Search of Memory: The Emergence of a New Science of Mind

*The Age of Insight: The Quest to Understand the Unconscious
in Art, Mind, and Brain, from Vienna 1900 to the Present*

ERIC R. KANDEL

REDUCTIONISM
IN ART AND
BRAIN SCIENCE

BRIDGING THE TWO CULTURES

Columbia University Press

New York

Columbia University Press
Publishers Since 1893
New York Chichester, West Sussex
cup.columbia.edu

Library of Congress Cataloging-in-Publication Data
Names: Kandel, Eric R., author.
Title: Reductionism in art and brain science : bridging the two cultures /
Eric R. Kandel.
Description: New York : Columbia University Press, 2016. | Includes bibliographical
references and index. | Description based on print version record and CIP data
provided by publisher; resource not viewed.
Identifiers: LCCN 2015049468 (print) | LCCN 2015048058 (ebook) |
ISBN 9780231542081 (electronic) | ISBN 9780231179621 (cloth : alk. paper)
Subjects: LCSH: Art—Psychology. | Reductionism. | Visual perception. |
Neurosciences and the arts.
Classification: LCC N71 (print) | LCC N71 .K355 2016 (ebook) |
DDC 700.1/9—dc23
LC record available at http://lccn.loc.gov/2015049468

Columbia University Press books are printed on
permanent and durable acid-free paper.
This book is printed on paper with recycled content.
Printed in the United States of America
c 10 9 8 7 6 5 4 3 2 1

Cover design: Lisa Hamm

Cover image: © 1998 Kate Rothko Prizel and Christopher Rothko/
Artists Rights Society (ARS), New York. Private Collection/
Photo © Christie's Images/Bridgeman Images

*To Lee Bollinger, who has created an environment at Columbia
that encourages the bridging of cultures.*

CONTENTS

CONTENTS

CONTENTS

CONTENTS

PART 1

THE TWO CULTURES
MEET IN THE
NEW YORK SCHOOL

INTRODUCTION

I n 1959 C. P. Snow, the molecular physicist who later became a novelist
(fig. i.1), declared that Western intellectual life is divided into two cul-
tures: that of the sciences, which are concerned with the physical nature
of the universe, and that of the humanities—literature and art—which are
concerned with the nature of human experience. Having lived in and expe-
rienced both cultures, Snow concluded that this divide came about because
neither understood the other's methodologies or goals. To advance human
knowledge and to benefit human society, he argued, scientists and human-
ists must find ways to bridge the chasm between their two cultures. Snow's
observations, which he delivered in the prestigious Robert Rede Lecture at
the University of Cambridge, have since spurred considerable debate over
how this could be done (see Snow 1963; Brockman 1995).[1]

My purpose in this book is to highlight one way of closing the chasm by
focusing on a common point at which the two cultures can meet and influ-
ence each other—in modern brain science and in modern art. Both brain
science and abstract art address, in direct and compelling fashion, questions
and goals that are central to humanistic thought. In this pursuit they share,
to a surprising degree, common methodologies.

While the humanistic concerns of artists are well known, I illustrate that
brain science also seeks to answer the deepest problems of human existence,

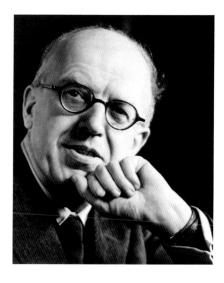

i.1 C. P. Snow (1905–1980)

using as an example the study of learning and memory. Memory provides the foundation for our understanding of the world and for our sense of personal identity; we are who we are as individuals in large part because of what we learn and what we remember. Understanding the cellular and molecular basis of memory is a step toward understanding the nature of the self. In addition, studies of learning and memory reveal that our brain has evolved highly specialized mechanisms for learning, for remembering what we have learned, and for drawing on those memories—our experience—as we interact with the world. Those same mechanisms are key to our response to a work of art.

Whereas the artistic process is often portrayed as the pure expression of human imagination, I show that abstract artists often achieve their goals by employing methodologies similar to those used by scientists. The Abstract Expressionists of the New York School of the 1940s and 1950s provide an example of a group that probed the limits of visual experience and extended the very definition of visual art. (For earlier attempts to bridge the two cultures, see E.O. Wilson 1977; Shlain 1993; Brockman 1995; Ramachandran 2011.)

Until the twentieth century, Western art had traditionally portrayed the world in a three-dimensional perspective, using recognizable images in a familiar way. Abstract art broke with that tradition to show us the world in a completely unfamiliar way, exploring the relationship of shapes, spaces, and colors to one another. This new way of representing the world profoundly challenged our expectations of art.

To accomplish their goal, the painters of the New York School often took an investigative, experimental approach to their work. They explored the nature of visual representation by reducing images to their essential elements of form, line, color, or light. I examine the similarities between their approach and the reductionism that scientists use by focusing on these artists as they move from figurative to abstract art—in particular, the work of the early reductionist painter Piet Mondrian and the New York painters Willem de Kooning, Jackson Pollock, Mark Rothko, and Morris Louis.

Reductionism, taken from the Latin word *reducere*, "to lead back," does not necessarily imply analysis on a more limited scale. Scientific reductionism often seeks to explain a complex phenomenon by examining one of its components on a more elementary, mechanistic level. Understanding discrete levels of meaning then paves the way for exploration of broader questions—how these levels are organized and integrated to orchestrate a higher function. Thus scientific reductionism can be applied to the perception of a single line, a complex scene, or a work of art that evokes powerful feelings. It might be able to explain how a few expert brushstrokes can create a portrait of an individual that is far more compelling than a person in the flesh, or why a particular combination of colors can evoke a sense of serenity, anxiety, or exaltation.

Artists often use reductionism to serve a different purpose. By reducing figuration, artists enable us to perceive an essential component of a work in isolation, be it form, line, color, or light. The isolated component stimulates aspects of our imagination in ways that a complex image might not. We perceive unexpected relationships in the work, as well as, perhaps, new connections between art and our perception of the world and new connections between the work of art and our life experiences as recalled in memory.

A reductionist approach even has the capacity to bring forth in the beholder a spiritual response to the art.

My central premise is that although the reductionist approaches of scientists and artists are not identical in their aims—scientists use reductionism to solve a complex problem and artists use it to elicit a new perceptual and emotional response in the beholder—they are analogous. For example, as I discuss in chapter 5, early in his career J.M.W. Turner painted a struggle at sea between a ship heading for a distant harbor and the natural elements: the storm clouds and rain bearing down on the ship. Years later, Turner recast this struggle, reducing the ship and the storm to their most elemental forms. His approach allowed the viewer's creativity to fill in details, thereby conveying even more powerfully the contest between the rolling ship and the forces of nature. Thus, while Turner explores the boundaries of our visual perception, he does so to engage us more fully with his art, not to explain the mechanisms underlying visual perception.

Reductionism is not the only fruitful approach to biology, or even to brain science. Important, often critical insights are gained by combining approaches, as is evident in the advances made in brain science through computational and theoretical analysis. Indeed, a major step forward in the study of the brain was the scientific synthesis that occurred in the 1970s, when psychology, the science of mind, merged with neuroscience, the science of the brain. The result of this unification was a new, biological science of mind that enables scientists to address a range of questions about ourselves: How do we perceive, learn, and remember? What is the nature of emotion, empathy, and consciousness? This new science of mind promises not only a deeper understanding of what makes us who we are but also to make possible meaningful dialogues between brain science and other areas of knowledge, such as art.

Science attempts to move us toward greater objectivity, a more accurate description of the nature of things. By examining the perception of art as an interpretation of sensory experience, scientific analysis can, in principle, describe how the brain perceives and responds to a work of art, and give us insights into how this experience transcends our everyday perception of the

world around us. The new, biological science of mind aspires to a deeper understanding of ourselves by creating a bridge from brain science to art, as well as to other areas of knowledge. If successful, this endeavor will help us understand better how we respond to, and perhaps even create, works of art.

Some scholars are concerned that focusing on reductionist approaches used by artists will diminish our fascination with art and trivialize our perception of its deeper truths. I argue to the contrary: appreciating the reductionist methods used by artists in no way diminishes the richness or complexity of our response to art. In fact, the artists I consider in this book have used just such an approach to explore and illuminate the foundations of artistic creation.

As Henri Matisse observed: "We are closer to attaining cheerful serenity by simplifying thoughts and figures. Simplifying the idea to achieve an expression of joy. That is our only deed."

CHAPTER 1

THE EMERGENCE OF AN
ABSTRACT SCHOOL OF ART
IN NEW YORK

In the years following the end of World War II, a number of artists began to wonder how art could still be meaningful in the aftermath of such a tragic period in world history, a period that encompassed the horrors of the Holocaust, the enormous loss of life on the battlefield, and the nuclear bombing of Hiroshima and Nagasaki. What visual language could possibly describe a world so transformed? Many artists in the United States felt compelled to create art that was unmistakably different from what had come before. One of the great artists of this period, Barnett Newman, wrote about his response and that of his fellow artists: "We are freeing ourselves of the impediments of memory, association, nostalgia, legend, myth, or what have you, that have been devices of Western European painting."

In their attempt to abandon European influences, the American artists created Abstract Expressionism, the first American art movement to gain international acclaim. In moving from figurative art to abstract art, the New York School of painters—notably, Willem de Kooning, Jackson Pollock, and Mark Rothko—and their colleague Morris Louis were taking a reductionist approach. That is, rather than depicting an object or image in all of its richness, they often deconstructed it, focusing on one or, at most, a few components and finding richness by exploring those components in a new way.

These New York artists of the 1940s and 1950s were surrounded by an exciting and influential group of intellectuals and owners of art galleries. Many European psychoanalysts, scientists, physicians, composers, and musicians—as well as the artists Piet Mondrian, Marcel Duchamp, and Max Ernst—had come to New York in the late 1930s and early 1940s to escape the war in Europe. They arrived soon after the opening of the Museum of Modern Art in 1929 and the Guggenheim Museum in 1939 and the rise of affluent, farsighted gallery owners such as Peggy Guggenheim and Betty Parsons. These museums, galleries, and émigré artists actively promoted the New York School as the first avant-garde school of painting that was authentically and emphatically American—in its spirit, its expansive scale, and its expression of individual freedom.

As a result, the center of modernist art shifted from Paris to New York. Thus, while Paris had been the New Jerusalem of the art world in 1900, New York became the New Jerusalem in the late 1940s. Mondrian, a pioneer reductionist who escaped from Europe when World War II broke out, described this shift in a virtual manifesto for abstraction in art: "In the metropolis, beauty is expressed in more mathematical terms; that is why it is the place . . . from which the New Style must emerge" (Spies 2011, 6:360). Roger Lipsey, a student of modern art, calls this period in the 1940s the "American epiphany," a revelation of the sacred qualities inherent in art. In fact, de Kooning, Pollock, Rothko, and Louis openly referred to the spiritual nature of their art.

The impact of the modernist movement was enhanced by the presence in New York of a contemporaneous school of art critics, particularly Harold Rosenberg of *The New Yorker* and Clement Greenberg of the *Partisan Review* and *The Nation*. These critics responded to the new art by developing a novel way of thinking about it. They focused almost exclusively on form and gesture, finding in the space, color, and structure of a painting the basis for a complex and satisfying critical perspective (Lipsey 1988, 298). Their enthusiasm for the New York School of painting was shared by Meyer Schapiro, professor of art history at Columbia University. He was the most important art historian of his time and the first art historian to appreciate

1.1 Harold Rosenberg (1906–1978)

the importance of the new American approach to art. As Barnett Newman pointed out, Schapiro was the first major scholar to defend American painting abroad.

Rosenberg (fig. 1.1) rose to prominence in 1952 with the publication of his essay "The American Action Painters" in *Art News*. He saw American art as moving along new lines. Painters, he wrote, were no longer concerned with the technical aspect of art, but were focused on treating the canvas as an "arena in which to act.... What was to go on the canvas was not a picture but an event." According to Rosenberg, the formal qualities of an artwork were not important. What was important was the creative act.

As a result of this highly influential essay, which offered the first coherent overview of "gestural abstraction," Rosenberg emerged as one of the important art critics of the early 1950s. Although he did not single out any individual artist, his analysis lent itself particularly well to de Kooning and

1.2 Clement Greenberg (1909–1994)

to Pollock; it applied much less well to the color-field painters, such as Rothko, Louis, and Kenneth Noland.

It was Greenberg (fig. 1.2), however, who ultimately formulated the aspirations of the New York School. He recognized and advocated not just for de Kooning and Pollock, whom he saw early on as moving abstraction to a dominant position in avant-garde art, but also for the color-field painters, who focused on combining colors to elicit strong emotional and perceptual responses in the beholder. Greenberg's almost single-handed defense of the new directions in what he termed "American style painting," at a time when modernism was almost categorically defined as the School of Paris, gave him unmatched credibility (Danto 2001).

Unlike Rosenberg, Greenberg did not see Pollock, Rothko, and the color-field painters of the New York School as breaking with historical tradition. Instead, he recognized in their work the culmination of an artistic

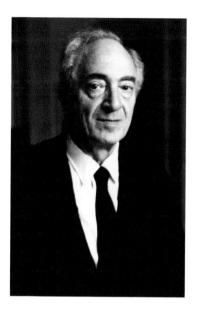

1.3 Meyer Schapiro (1904–1996)

tradition that had begun with Claude Monet, Camille Pissarro, and Alfred Sisley, then evolved through Paul Cézanne into analytic Cubism. In this progression, painting became increasingly focused on what Cézanne saw as its essential nature: the making of marks on a flat surface (Greenberg 1961). In the late 1950s and the 1960s, particularly in his 1964 essay "After Abstract Expressionism," Greenberg placed progressively more emphasis on the color-field painters, whom he saw as developing an even more radical approach to conventional easel painting.

Schapiro (fig. 1.3), unlike Greenberg and Rosenberg, did not identify with a particular school or painter, but brought his rich knowledge of art history and theory to bear on the contemporary art scene. As a result, he exerted a dramatic influence on contemporary artists, notably de Kooning. In the 1950s and 1960s, the heyday of Abstract Expressionism, Schapiro, Rosenberg, and Greenberg were leading voices on art in the United States.

Despite their later revolutionary intentions, the painters of the New York School were rooted in the figurative art of the 1930s. They all emerged during the Great Depression and began their careers painting in styles that were influenced by both social realism and the regionalist movement. Many of them, including de Kooning, Pollock, Rothko, and Louis, benefited from the Federal Art Project, which operated from 1934 to 1943. This was part of President Franklin Roosevelt's New Deal, a plan to jump-start the national economy during the Great Depression by giving people work. The Federal Art Project recruited and supported numerous artists during those lean years, putting them to work on public projects. As a result, the artists interacted with and influenced one another extensively throughout their careers. The networks they formed were very much like the interactive, productive networks often formed by scientists.

The New York painters not only influenced each other, they also influenced subsequent generations of artists, including Alex Katz and Alice Neel, who returned to figuration using reductive approaches. The painters of the New York School also influenced Andy Warhol, Jasper Johns, and the emergence of Pop Art. Finally, along with Neel and Johns, they influenced Chuck Close in his successful efforts to follow reduction with synthesis.

PART 2

A REDUCTIONIST
APPROACH
TO BRAIN SCIENCE

CHAPTER 2

THE BEGINNING OF
A SCIENTIFIC APPROACH TO
THE PERCEPTION OF ART

Before the emergence of a systematic science of the brain in the second half of the twentieth century, researchers relied on psychology and on the emerging understanding of visual perception to investigate the workings of the human mind. One focus of inquiry was on an activity that is quintessentially human—how we perceive and create works of art.

This raised the question: Can any aspect of art, which is a creative and subjective experience, be studied objectively? To answer this, and to understand how abstract art relates to this inquiry, we must first explore what we know about how the mind responds to figurative art, which more closely resembles our natural world.

THE BEHOLDER'S SHARE

The question of how we respond to figurative art was first addressed by Alois Riegl (fig. 2.1), Ernst Kris, and Ernst Gombrich at the Vienna School of Art History. Riegl, Kris, and Gombrich attained international renown at the turn of the twentieth century for their efforts to establish art history as a scientific discipline by grounding it in psychological principles (Riegl 2000;

2.1 Alois Riegl (1858–1905)

Kris and Kaplan 1952; Gombrich 1982; Gombrich and Kris 1938, 1940; see also Kandel 2012).

Riegl emphasized an obvious but previously ignored psychological aspect of art: that art is incomplete without the perceptual and emotional involvement of the viewer. Not only do we collaborate with the artist in transforming a two-dimensional figurative image on a canvas into a three-dimensional depiction of the visual world, we interpret what we see on the canvas in personal terms, thereby adding meaning to the picture. Riegl called this phenomenon the "beholder's involvement." Based on ideas derived from Riegl's work and on insights that began to emerge from cognitive psychology, the biology of visual perception, and psychoanalysis, Kris and Gombrich (figs. 2.2, 2.3) went on to develop a new view of this concept, which Gombrich referred to as the *beholder's share*.

Kris, who later became a psychoanalyst, started things off by studying ambiguity in visual perception. He argued that every powerful image is

2.2 Ernst Kris (1900–1957)

2.3 Ernst Gombrich (1909–2001)

inherently ambiguous because it arises from experiences and conflicts in the artist's life. The viewer responds to this ambiguity in terms of his or her own experiences and conflicts, recapitulating in a modest way the experience of the artist in creating the image. For the artist, the creative process is also interpretative, and for the beholder the interpretative process is also creative. Because the extent of the viewer's contribution depends on the degree of ambiguity in the image, a work of abstract art, with its lack of reference to identifiable forms, arguably puts greater demands on the beholder's imagination than a figurative work does. Perhaps it is these demands that make abstract works seem difficult to some viewers, yet rewarding to those who find in them an expansive, transcendent experience.

THE INVERSE OPTICS PROBLEM: INTRINSIC LIMITATIONS OF VISUAL PERCEPTION

Gombrich embraced Kris's ideas about the beholder's response to the ambiguity in a painting and extended them to all visual perception. In the process, he came to understand a crucial principle of brain function: our brain takes the incomplete information about the outside world that it receives from our eyes and makes it complete.

As we shall see in chapter 4, the image on our retina is first deconstructed into electrical signals that describe lines and contours, creating a boundary around a face or an object. As these signals move through the brain, they are recoded and, based on Gestalt rules of organization and on prior experience, they are reconstructed and elaborated into the image we perceive. Amazingly, each of us is able to create a rich, meaningful image of the external world that is remarkably similar to the image seen by others. It is in the construction of these internal representations of the visual world that we see the brain's creative process at work. As the cognitive psychologist Chris Frith of the Wellcome Center for Neuroimaging at University College London writes:

What I perceive are not the crude and ambiguous cues that impinge from the outside world onto my eyes and my ears and my fingers. I perceive something much richer—a picture that combines all these crude signals with the wealth of past experience. . . . Our perception of the world is a fantasy that coincides with reality. (Frith 2007)

Any image projected onto the retina of the eye has countless possible interpretations. The Anglo-Irish philosopher George Berkeley, Bishop of Cloyne, grasped this central problem of vision as early as 1709, when he wrote that we do not see material objects, but rather the light reflected off them (Berkeley 1709). As a result, no two-dimensional image projected onto our retina can ever directly specify all three dimensions of an object. This fact, and the difficulty it raises for understanding our perception of any image, is referred to as the *inverse optics problem* (Purves and Lotto 2010; Kandel 2012; Albright 2013).

The inverse optics problem arises because any given image projected onto the retina can be generated by objects of different sizes, with different physical orientations, and at different distances from the observer. For example, a souvenir model of the Eiffel Tower held close to your eye may appear identical in shape and size to the actual Eiffel Tower as seen from across the Champ de Mars. As a result, the actual source of our perception of any three-dimensional object is inherently uncertain. Gombrich fully appreciated this problem and cited Berkeley's observation that "the world as we see it is a construct slowly built up by every one of us in years of experimentation" (Gombrich 1960).

Although our brain does not receive enough information to reconstruct an object accurately, we do it all the time—and with surprising consistency from person to person. How does this occur? The noted nineteenth-century physician and physicist Hermann von Helmholtz argued that we solve the inverse optics problem by including two additional sources of information: bottom-up information and top-down information (see Adelson 1993).

Bottom-up information is supplied by computations that are inherent in the circuitry of our brain. These computations are governed by universal rules that are largely built into the brain at birth by biological evolution and enable us to extract key elements of images in the physical world, such as contours, intersections, and the crossings of lines and junctions. Edward Adelson (1993) and subsequently Dale Purves (2010), two students of vision who have revisited the inverse optics problem, conclude that our visual system must have evolved primarily to solve this fundamental problem. We use these rules to discern objects, people, and faces; to ascertain their placement in space (perspective); to reduce ambiguity; and ultimately to construct visual worlds of great subtlety, beauty, and practical value. As a result, each person's visual system extracts pretty much the same essential information from the environment. This is why, despite incomplete information and potential ambiguities, even young children can interpret images quite accurately. It is also why babies can recognize human faces very early in their lives.

Many of these innate rules we take for granted. For example, our brain realizes that the sun is always above us, no matter where we are. We therefore expect light to come from above. If it does not—as in a visual illusion—our brain can be tricked.

As the psychologist of art Robert Solso has written, bottom-up perception is simply a matter of nativist perception: "People have certain inborn ways of seeing, in which visual stimuli, including art, are initially organized and perceived. Causally speaking, nativist perception is 'hard-wired' in the sensory-cognitive system" (Solso 2003). Bottom-up information processing depends largely on low- and intermediate-level vision (Kandel 2012). Abstract art, as we will see, subverts the innate rules of perception and relies more extensively on top-down information than does figurative art.

Top-down information refers to cognitive influences and higher-order mental functions such as attention, imagery, expectations, and learned visual associations. Because bottom-up processing cannot resolve all of the perplexing information we receive from our senses, the brain must engage top-down processing to resolve the remaining ambiguities. We must guess,

based on experience, the meaning of the image in front of us. Our brain does this by constructing and testing a hypothesis. Top-down information places the image into a personal psychological context, thereby conveying different meanings about it to different people (Gilbert 2013; Albright 2013).

Top-down processing is also critical for suppressing components of the visual scene that we unconsciously deem irrelevant. Our recognition of an image takes place serially; it requires us to shift the focus of our attention frequently, linking relevant components of the scene and suppressing irrelevant components. Thus the creativity of the beholder's share that Kris described derives in large part from top-down processing.

Perception incorporates the information our brain receives from the external world with knowledge based on learning from earlier experiences and hypothesis testing. We bring this knowledge—which is not necessarily built into the developmental program of our brain—to bear on every image we see. Thus when we look at an abstract work of art, we relate it to our entire life experience of the physical world: people we have seen and known, environments we have been in, as well as memories of other works of art we have encountered.

Frith summarizes Helmholtz's insight into the nature of visual perception in this way: "We do not have direct access to the physical world. It may feel as if we have direct access, but this is an illusion created by our brain" (Frith 2007).

In a sense, to see what is represented by the paint on a canvas, we have to know beforehand what sort of image we might expect to see in a painting. Our familiarity with the natural environment, as well as with centuries of landscape paintings, helps us to discern almost immediately a wheat field in the brushstrokes of Vincent van Gogh or a lawn in the Pointillist dots of Georges Seurat. In this way the artist's modeling of physical and psychic reality parallels the intrinsically creative operations of our brain in everyday life.

THE BIOLOGY OF
THE BEHOLDER'S SHARE

—

Visual Perception and Bottom-Up Processing in Art

To appreciate what brain science can tell us about the beholder's share—how we respond to a work of art—we need first to understand how our visual experiences are generated by the brain and how the sensory signals that are processed into bottom-up perceptions are modified by top-down influences and by the brain systems concerned with memory and emotion. We will first consider the bottom-up processes.

You are probably confident that you see the world as it is. You rely on your eyes to give you accurate information so that your actions are based on reality. While our eyes do provide information we need to act, they do not present our brain with a finished product. The brain actively extracts information about the three-dimensional organization of the world from the two-dimensional image on the retina. What is so wonderful—indeed, almost magical—about our brain is that we can perceive an object based on incomplete information, and we can perceive it as being the same under strikingly different conditions of lighting and context.

How does the brain do that? A guiding principle in its organization is that every mental process—perceptual, emotional, or motor—relies on distinct groups of specialized neural circuits located in an orderly, hierarchical arrangement in specific regions in the brain. However, while brain structures are separable conceptually at every level of organization, they are

related to one another anatomically and functionally, and therefore cannot be separated physically.

THE VISUAL SYSTEM

The visual system is central to the beholder's share. How is it organized? What levels of organization in the visual system come into play, for example, when we look at a face in a portrait?

In primates, and especially in humans, the cerebral cortex, the heavily wrinkled outer layer of the brain, is typically thought to be the most important region for higher cognition and consciousness. The cerebral cortex has four lobes: occipital, temporal, parietal, and frontal. The occipital lobe, located at the back of the brain, is where visual information from the eyes enters the brain; the temporal lobe is where visual information about faces is processed (fig. 3.1).

Vision is the process of *discovering* from images *what* is present in the visual world and *where* it is. This implies that the brain has two parallel processing streams, one that deals with what an image is about and one that deals with where it is located in the world. These two parallel processing streams in the cerebral cortex are the *what pathway* and the *where pathway* (fig. 3.1). Both pathways start in the retina, the light-sensitive layer of cells at the back of the eye.

Visual information begins as reflected light. The wavelengths of light, such as those reflected by the face of a person or a portrait, are refracted by the cornea of the eye and projected onto the retina. The resulting retinal image is essentially a pattern of light that changes in intensity and wavelength over space and time (Albright 2015).

Retinal cells fall into two categories: rods and cones. Rods are exquisitely sensitive to the intensity of light and are used for black-and-white vision. Cones, in contrast, are less sensitive to light but carry information about color. Cones come in three types, each of which responds to different but overlapping wavelengths of light that represent all the colors in the visible

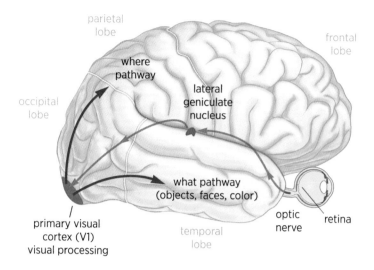

parietal
lobe

frontal
lobe

where
pathway

lateral
geniculate
nucleus

occipital
lobe

what pathway
(objects, faces, color)

optic
nerve

retina

primary visual
cortex (V1)
visual processing

temporal
lobe

3.1 The visual system. Information flows from the retina to the lateral geniculate nucleus through the optic nerve. The lateral geniculate nucleus sends information to the primary visual cortex, which gives rise to two major pathways: the *where* pathway concerned with where an object or a person is located and the *what* pathway which is concerned with what an object is or who a person is.

spectrum. They are located predominantly in the center of the retina—an area called the fovea, where fine visual detail is registered best—whereas rods specialized for black-and-white vision are more prevalent on the periphery of the retina.

The retina sends visual information to the lateral geniculate nucleus, a group of cells located in the thalamus, a structure deep within the brain that relays information to the primary visual cortex (also called the striate cortex, or area V1). The primary visual cortex is located in the occipital lobe at the back of the brain and is where visual information enters the brain (fig. 3.1). According to Semir Zeki, a pioneer in the study of visual processing at University College London, "V1, in brief, acts much like a post office, distributing different signals to different destinations; it is but the first, though essential, stage in an elaborate machinery designed to extract the essential information from the visual world" (Zeki 1998).

The visual information that reaches the primary visual cortex is relatively simple and lightly processed information about what things are and where they are. It is difficult to imagine that information about what an object is can be divorced from where it is, yet that is exactly what happens next: the information leaves the primary visual cortex in two separate pathways.

The *what* pathway runs from the primary visual cortex, area V1, to several regions near the bottom of the brain, including the unimaginatively named areas V2, V3, and V4, and on to the inferior temporal cortex, where face processing occurs. This information-processing stream, also known as the *inferior pathway* because of its location in the brain, is concerned with the nature of objects or faces: their shape, color, identity, motion, and function (fig. 3.1). The *what* pathway is of particular interest in the context of portraiture. It not only carries information about form but also is the only visual pathway that leads directly to the hippocampus, the structure in the brain that is concerned with the explicit memory of people, places, and objects and that is recruited by the beholder's brain for top-down processing.

The *where* pathway runs from the primary visual cortex to areas near the top of the brain. This pathway, also known as the *superior pathway*, is concerned with the processing of motion, depth, and spatial information to determine where an object is in the external world.

The separation between the two pathways is not absolute, because we often need to combine information about where and what an object is. For that reason, the pathways can exchange information along their courses. But the separation is quite pronounced, and it is something that cannot happen in the physical world or in a simple photograph: an object is *what* it is and *where* it is at the same time. As we shall see, art is often quite successful in exploiting the fact that seemingly inseparable information is in fact separated in our brain.

Together with the *where* pathway, the *what* pathway performs three types of visual processing. *Low-level* processing occurs in the retina and is concerned with detecting an image. *Intermediate-level* processing begins in the primary visual cortex. A visual scene comprises thousands of line segments and surfaces. Intermediate-level vision discerns which surfaces and

boundaries belong to specific objects and which are part of the background. Together, low- and intermediate-level visual processing identify the areas of an image that are related to particular objects and the background area that is not. Intermediate-level processing is also concerned with contour integration, a grouping operation designed to combine features into distinct objects. These two types of visual processing are critical for the bottom-up processing of the beholder's share.

High-level visual processing integrates information from a variety of regions in the brain to make sense of what we have seen. Once this information has reached the highest level of the *what* pathway, top-down processing occurs: the brain uses cognitive processes such as attention, learning, and memory—everything we have seen and understood before—to interpret the information. In the case of a portrait, this leads to conscious perception of the face and recognition of the person who is depicted (see Albright 2013; Gilbert 2013b). Information in the *where* pathway is processed in much the same way. Thus the *what* and *where* pathways of our visual system also function as a parallel-processing perceptual system.

The existence of two visual pathways in our brain poses a binding problem for neural integration. How does the brain combine the pieces of information about a particular object provided by these parallel processing streams? Anne Treisman has found that binding requires focused attention on an object (Treisman 1986). Her studies suggest that visual perception involves two processes in addition to what and where. First comes a preattentive process, which is concerned only with detection of the object. In this bottom-up process the beholder rapidly scans an object's global features—such as its shape and texture—and focuses on distinctions between figure and ground by encoding all the useful elementary properties of the image simultaneously: its color, size, and orientation. This is followed by an attentive process, a top-down searchlight of attention that allows higher centers in the brain to infer that since these several features occupy one location, they must be bound together (Treisman 1986; Wurtz and Kandel 2000).

Thus, once information from the *what* pathway reaches the higher regions of the brain, it is reappraised. This top-down reappraisal operates on

four principles: it disregards details that are perceived as behaviorally irrelevant in a given context; it searches for constancy; it attempts to abstract the essential, constant features of objects, people, and landscapes; and, particularly important, it compares the present image to images encountered in the past. These biological findings confirm Kris and Gombrich's inference that visual perception is not a simple window on the world, but truly a creation of the brain.

THE FACE-PROCESSING COMPONENT
OF THE VISUAL SYSTEM

The visual system's segregation of function becomes obvious in cases of brain damage. Damage to any given area of the visual system produces very specific effects. For example, damage to the inferior medial temporal lobe compromises our ability to recognize faces, a condition known as face blindness, or prosopagnosia. This condition was first discovered in 1946 by the neurologist Joachim Bodamer (1947). People with damage in the front of the inferior temporal cortex can recognize a face as a face but cannot tell whose face it is. People with damage to the back of the inferior temporal cortex cannot see a face at all. In Oliver Sacks's famous story "The Man Who Mistook His Wife for a Hat," a man with face blindness tried to pick up his wife's head and put it on his head because he mistook her head for his hat (Sacks 1985). A modest degree of face blindness is not rare; about 10 percent of people are born with it.

Bodamer's discovery was important because, as Charles Darwin first emphasized, face recognition is essential for our functioning as social beings. In *The Expression of Emotions in Man and Animals* (1872), Darwin argues that we are biological creatures who have evolved from simpler animal ancestors. Evolution is driven by sexual selection, and therefore sex is central to human behavior. A key to sexual attraction—indeed, to all social interaction—is facial expression. We recognize each other and even ourselves through our faces.

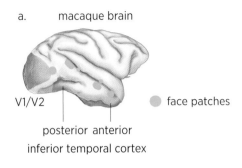

3.2 a. Multiple areas of the nonhuman primate brain respond to faces. b. Rembrandt's self-portrait. c. Rembrandt's self-portrait from a simple line drawing.

Being social animals, we need to communicate not only our ideas and plans but also our emotions, and we do that through our faces. We convey emotions in large part through a limited number of facial expressions. Thus, you can attract another person by smiling seductively, or you can keep that person away by looking foreboding.

Since all faces have the same number of features—one nose, two eyes, and one mouth—the sensory and motor aspects of emotional signals communicated by the face must be universal, independent of culture. Darwin argued that both the ability to form facial expressions and the ability to

read the facial expressions of others are innate, not learned. Years later, experiments in cognitive psychology showed that face recognition begins in infancy.

What is it about faces that makes them special? Even very powerful computers have great difficulty recognizing faces, yet a child of two or three years can readily learn to distinguish up to two thousand different faces. Moreover, we can readily recognize Rembrandt's self-portrait from a simple line drawing (figs. 3.2b and c): the slight exaggeration in the drawing actually helps with recognition. These observations raise another question: What is it about our brain that enables us to recognize faces so easily?

Our brain devotes more computational power, more bottom-up processing, to faces than to any other object. Charles Gross at Princeton, and later Margaret Livingstone, Doris Tsao, and Winrich Freiwald at Harvard, carried Bodamer's findings several important steps further and in so doing made a number of important discoveries about the brain's machinery for analyzing faces (Tsao et al. 2008; Freiwald et al. 2009; Freiwald and Tsao 2010). Using a combination of brain imaging and electrical recording of signals from individual cells, these scientists found six small structures in the temporal lobe of macaque monkeys that light up in response to a face (fig. 3.2a). The scientists called these structures *face patches*. They found a similar, although smaller, set of face patches in the human brain.

When the scientists recorded electrical signals from cells in the face patches, they found that different patches respond to different aspects of the face: head-on view, side view, and so on. The cells are also sensitive to changes in a face's position, size, and direction of gaze, as well as to the shape of the various parts of the face. Moreover, face patches are interconnected and serve as a processing stream for information about the face.

Figure 3.3 shows a cell in a monkey's face patch responding to various images. Not surprisingly, the cell fires very nicely when the monkey is shown a picture of another monkey (a). The cell fires even more dramatically in response to a cartoon face (b). This finding indicates that monkeys, like people, respond more powerfully to cartoons than to real objects because

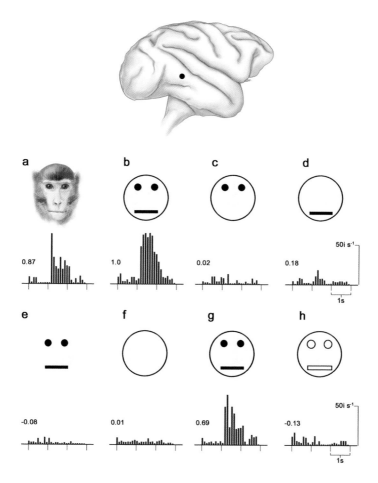

3.3 Holistic face detection. *Top*: Recording site and location of a face cell. *Bottom* (a–h): the height of the bars indicates the firing rate of action potentials and thus the strength of face recognition in response to various types of facial stimuli.

the features in a cartoon are exaggerated. Such exaggerated responses are mediated by the built-in machinery of bottom-up processing. The association of a particular face with a particular person or the recollection of a face seen before is added to this bottom-up processing by top-down processing, whose mechanisms we will consider further in chapter 8.

The cells in a monkey's face patch respond to the total form, or *Gestalt*, of the face, not to isolated features: a face has to be complete in order to elicit a response. When the monkey is shown two eyes in a circle (c), there is no response. A mouth and no eyes (d) elicits no response. Two eyes and a mouth—a nose is not necessary—inside a square (e), also no response. If the monkey is shown only a circle (f), there is no response. The cell responds only to two eyes and a mouth inside a circle (g). If the circle and the mouth are only outlined (h), there is no longer a response. In addition, if the monkey is shown an inverted face, it does not respond.

Computer models of vision suggest that some facial features are defined by contrast (Sinha 2002). For example, the eyes tend to be darker than the forehead, regardless of lighting conditions. Moreover, computer models suggest that such contrast-defined features signal the brain that a face is present. To test these ideas, Ohayon, Freiwald, and Tsao (Ohayon et al. 2012). presented monkeys with a series of artificial faces, each of whose features was assigned a unique luminous value ranging from dark to bright. They then recorded the activity of individual cells in the monkeys' middle face patches in response to the artificial faces and found that the cells do respond to contrasts between facial features. Moreover, most of the cells are tuned to contrasts between specific pairs of features, the most common being those in which the nose is brighter than one of the eyes.

These preferences agree with those predicted by the computer model of vision. But since results in both the monkey and computer studies are based on artificial faces, the obvious question is whether they extend to real faces.

To answer that question, Ohayon and his colleagues studied the response of the cells to images of a large variety of real faces. They found that responses increased with the number of contrast-defined features. Specifically, the cells did not respond to real faces containing only four contrast-defined features, although they did recognize them as faces. But they responded well to faces containing eight or more contrast-defined features.

Tsao, Freiwald, and their colleagues had found earlier (Tsao et al. 2008) that cells in these face patches respond selectively to the shape of some facial

features, such as noses and eyes. Ohayon's findings now showed that the preference for a particular facial feature depends on its luminance relative to other parts of the face. This may be one of the reasons that makeup is effective in highlighting women's facial features. Importantly, most of the cells in the middle face patches respond both to contrast and to the shape of facial features. This fact leads us to an important conclusion: contrast is useful for face detection, and shape is useful for face recognition.

These studies have shed new light on the nature of the templates our brain uses to detect faces. Behavioral studies suggest further that there is a powerful link between the brain's face detection machinery and the areas that control attention, which may explain why faces and portraits grab our attention so powerfully. Moreover, this explains why our response to Schoenberg's figurative self-portrait (fig. 5.10) is so different from our response to his more abstract versions (figs. 5.11–5.13). The figurative version gives a lot of detail to activate our face cells, whereas the abstract versions do not activate the face cells, leaving more to our imagination.

The multistage processing stream for faces has turned out to represent a general principle of vision. Colors and shapes are also represented in multistage processing patches and are also located in the inferior temporal lobe, as we shall see in chapter 10.

OTHER COMPONENTS OF THE HUMAN NERVOUS SYSTEM

The central nervous system comprises the brain and the spinal cord. It can best be understood as containing several clearly defined structural levels of organization, as outlined by Patricia Churchland and Terrence Sejnowski (1988). These levels are based on the spatial scale at which an anatomical organization can be identified (fig. 3.4). Thus, at the highest level is the central nervous system, while at the lowest is the individual molecule.

In terms of the new science of mind, the highest level is the brain, an astonishingly complex computational organ that constructs our perception

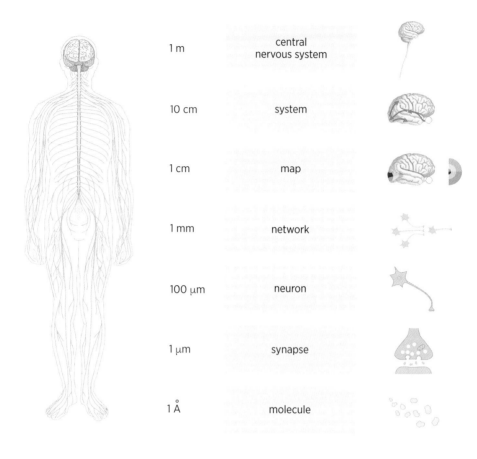

1 m	central nervous system
10 cm	system
1 cm	map
1 mm	network
100 μm	neuron
1 μm	synapse
1 Å	molecule

3.4 The nervous system has many levels of structural organization ranging from the central nervous system to molecules, and the spatial scale at which the corresponding anatomical organizations can be identified varies over many orders of magnitude. *Left*: Drawing of the human brain, the spinal cord, and the peripheral nerves. *Right*: Schematic diagrams illustrating (from top to bottom) the central nervous system; an individual brain system (vision); a map of the visual field as relayed via the retina and represented in the primary visual cortex; a small network of neurons; a single neuron; a chemical synapse; and molecules. Relatively less is known about the properties of networks compared with the detailed knowledge we have of synapses and the general organization of pathways in the sensory and motor systems.

of the external world, fixes our attention, and controls our actions. The next level comprises the various systems of the brain: the sensory systems such as vision, hearing, and touch and the motor systems for movement. The next level is maps, such as the representation of the visual receptors of the retina on the primary visual cortex. The level below maps is that of the networks, such as the reflex movements of the eyes when a novel stimulus appears at the edge of our visual field. Below that is the level of neurons, then synapses, and finally the molecules.

THE INTERACTION OF VISION AND TOUCH AND THE RECRUITMENT OF EMOTION

Modern brain science has revealed that several regions of the brain thought to be specialized for processing visual information are also activated by touch (Lacey and Sathian 2012). One particularly important region that responds to both the sight and the feel of an object is located in the lateral occipital cortex (fig. 3.5). The texture of an object activates cells in a neighboring region of the brain, the medial occipital cortex, regardless of whether the object is perceived by the eye or by the hand (Sathian et al. 2011). This relationship is thought to explain, in part, why we can easily identify and distinguish between the different materials of an object—skin, cloth, wood, or metal—and can often do so at a glance (Hiramatsu et al. 2011).

In exploring further how our brain creates the external world, imaging studies have revealed that the brain's coding of visual information about materials changes gradually in the course of viewing an object. When we first look at a painting or any other object, our brain processes only visual information. Shortly thereafter, additional information processed by other senses is thought to come into play, resulting in a multisensory representation of the object in higher regions of the brain. Combining visual information with information from other senses enables us to categorize different materials (Hiramatsu et al. 2011). In fact, the perception of texture, which is central to both Willem de Kooning's and Jackson Pollock's paintings, is

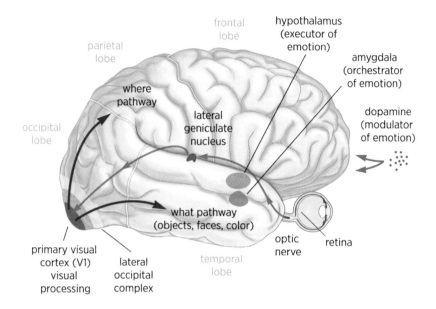

3.5 Areas involved in the early stages of visual processing (V1), in visual-tactile interactions (lateral occipital cortex) and in emotional response to a visual object or person (amygdala, hypothalamus, and dopaminergic pathways).

intimately tied to visual discrimination and to associations in these higher regions of the brain (Sathian et al. 2011), which have robust and efficient mechanisms for processing textured images. Combining information from several senses is critical to the brain's experience of art.

In addition to their interaction with each other, vision and touch, both alone and in combination, are capable of recruiting the emotional systems of the brain. These consist of the amygdala, which orchestrates emotions, both positive and negative; the hypothalamus, which executes and makes us feel emotion; and the dopaminergic modulatory system, which enhances the appreciation of emotion (see fig. 3.5). We will explore these systems further in chapter 10.

Modern abstract art was predicated on the liberation of line and the liberation of color. We have seen here how lines and forms are processed

in the brain. Equally important for abstract art is the processing of color, which makes an impact on the beholder not only because of its importance in helping us discern the spatial details of form (see, for example, fig. 10.1) but also because of color's extraordinary ability, whether alone or in combination with line and form, to elicit strong emotional responses. We will explore emotional responses to color further in chapters 8 and 10.

THE BIOLOGY OF LEARNING AND MEMORY

—

Top-Down Processing in Art

Reductionist approaches are well defined in science, where they are commonly selected as a strategy for solving a particular complex problem by exploring its simplest representation. Reductionism serves a somewhat different purpose in art, which we shall examine later. This chapter considers the elementary neuronal mechanisms that contribute to top-down processing in art and illustrates how they were delineated by using a reductionist approach.

A striking example of a reductionist approach in biology is the study of heredity. Until the beginning of the Second World War, little was known about the fundamental nature of heredity or even the molecules that distinguish living from nonliving matter. This awkward state of affairs prompted Erwin Schrödinger, a Nobel Prize–winning physicist who had pioneered the study of quantum mechanics, to write a book based on the question, What is life? Specifically, he asked, "How can the events in *space* and *time* which take place within the spatial boundary of a living organism be accounted for by physics and chemistry?" (Schrödinger 1944).

Schrödinger focused on the work of Thomas Hunt Morgan at Columbia University, which had shown that genes are discrete entities on chromosomes. But nothing was known about the physical structure or chemical composition of genes. Particularly perplexing was their dual nature: genes are both stable, so traits can be passed on from generation to generation,

and mutable, so they can change and pass those changes on from one generation to the next. Schrödinger speculated that genes contain an "elaborate code-script" that specifies all the future development of the organism. Thus he pinpointed the central task of biology: to solve the mystery of how information contained within the genes of an organism can specify that organism and how that information can be transmitted and altered.

Around the same time that Schrödinger's book appeared, the journal *Genetics* carried a revolutionary article by two biologists, Salvador Luria and Max Delbrück. Reductionism had been used successfully in physics, but Luria and Delbrück were the first scientists to apply it to biology. They showed that bacteria—simple single-celled organisms—could be used as model systems to study the complex processes of gene actions and heredity. But this was only the beginning. In 1944, Oswald Avery at Rockefeller University used studies of bacteria to provide the first evidence that the chemical component of genes that is responsible for inheritance is DNA.

In 1952 James Watson, a biologist, and Francis Crick, a physicist who had become fascinated with the biology of the gene after reading Schrödinger's book, began a collaboration to follow up on Avery's finding. Watson was convinced that deciphering the structure of DNA would solve the most important riddle of genetics—in fact, the most important question in all of biology: how DNA is copied and how genetic information is transmitted faithfully from generation to generation. Watson and Crick's subsequent discovery of the double helical structure of DNA indicated how it is copied and transmitted across generations. As Watson put it, the secret of life had been revealed. Several years later, François Jacob and Jacques Monod at the Institute Pasteur in Paris returned to bacteria and worked out a general picture of how genes are regulated—that is, how they are switched on and off. These amazing insights were realized by the application of reductionist strategies to the biology of inheritance.

But what about the biology of the brain? Can a reductionist approach work on something much more complex than the gene? Can it be applied to brain science to address problems of humanistic importance, and can reductionism contribute to our understanding of top-down processes—that

is, how our learned experiences and visual associations influence our perception and enjoyment of art? To answer those broad questions, let us focus on the learned associations of top-down processes and examine three more specific questions: How do we learn? How do we remember? And how do learning and remembering relate to top-down processing in our response to works of art?

A REDUCTIONIST APPROACH TO LEARNING AND MEMORY

From a broad humanistic perspective, the study of learning and memory is endlessly fascinating because it addresses one of the most remarkable aspects of human behavior: our ability to generate new ideas from experience. Learning is the mechanism whereby we acquire new knowledge about the world, and memory is the mechanism whereby we retain that knowledge over time. We are who we are as individuals in great part because of what we learn and remember. But learning and memory also play a larger role in human experience.

Despite its discrete nature, learning has broad cultural ramifications. We know what we know about our world and its civilizations because of what we have learned. In the largest sense, learning goes beyond the individual's acquisition of knowledge to the transmission of culture from generation to generation. It is a critical vehicle for behavioral adaptation and the only vehicle for social progress. Indeed, animals and people have only two major types of mechanisms available for adapting behaviorally to their environment: biological evolution and learning. Of these, learning is by far the more efficient. Changes brought about by biological evolution are slow, often requiring thousands of years in higher organisms, whereas changes produced by learning can be rapid, occurring repeatedly within the life span of an individual.

The potential for learning parallels the complexity of the nervous system. Thus, while the ability to learn and to remember is characteristic of all moderately evolved animals, it reaches its highest form in human beings.

In us, learning has led to the establishment of a completely new kind of evolution—cultural evolution—which has largely supplanted biological evolution as a means of transmitting knowledge and adaptations across generations. Our capacity for learning is so remarkably developed that human societies change almost exclusively by cultural evolution. In fact, there is no strong evidence of any biological change in the size or structures of the human brain since *Homo sapiens* appeared in the fossil record some 50,000 years ago. All human accomplishments, from antiquity to modern times, are the product of cultural evolution, and therefore of memory.

The biological study of learning raises some familiar philosophical questions: What aspects of the organization of the human mind are innate? How does our mind acquire knowledge of the world?

Serious thinkers in every generation have struggled with these questions. By the end of the seventeenth century, two opposing views had emerged. The British empiricists John Locke, George Berkeley, and David Hume argued that our mind does not possess innate ideas; rather, all knowledge derives from sensory experience and is therefore learned. By contrast, the continental philosophers René Descartes, Gottfried Leibniz, and particularly Immanuel Kant argued that we are born with *a priori* knowledge; our mind receives and interprets sensory experience in an innately determined framework.

During the early nineteenth century, it gradually became clear that the methods of philosophy—observation, introspection, argument, and speculation—could not, by themselves, either distinguish or reconcile conflicting views about how learning occurs, because the answers would depend upon knowing what goes on in the brain when we learn.

MERGING THE PSYCHOLOGY AND BIOLOGY OF LEARNING AND MEMORY

Mind is a set of operations carried out by the brain. For biologists interested in how the brain performs these mental functions, the study of learning

has further appeal: unlike thought, language, and consciousness, learning is amenable to reductionist analysis on both a behavioral and a molecular level.

At the beginning of the twentieth century two forms of *associative learning* were discovered: *classical* and *operant conditioning*. Classical conditioning, discovered by Ivan Pavlov, involves an animal or a person learning to associate two stimuli with each other. When a neutral stimulus, such as a tone, is followed repeatedly by a reinforcing stimulus, such as a shock, it causes the animal or the person to learn to withdraw from the neutral stimulus. Operant conditioning, discovered by Edward Thorndike, involves an animal learning to associate a stimulus with a response. If an animal is shown a lever that results in a food reward, the animal will learn to press the lever and will do so progressively more rapidly and efficiently. As a result of these advances, elementary forms of learning and memory were well characterized on a purely behavioral level in both experimental animals and human beings by the first half of the twentieth century. These basic forms of learning represent the most clearly delineated and, for the experimenter, most easily controlled of any mental processes.

At the same time that Pavlov, Thorndike, and B. F. Skinner were exploring the psychology of learning and memory, Alois Riegl and his younger disciples Ernst Kris and Ernst Gombrich were working to establish art history as a scientific discipline by grounding it in psychology. As we have seen, Kris and Gombrich showed that learning and memory are essential to visual perception and thus to our response to art. That response entails not simply seeing a work, but also associating it—through top-down processing—with memories of other works of art we have seen and with other life experiences that the work brings to mind.

Early generations of psychologists thought they could understand learning and memory without understanding the biology of the brain because they believed that these mental processes do not map directly onto the brain. With the emergence of the new science of mind, however, it has become evident that all mental processes are biological processes and that our understanding of any mental process is greatly enhanced by relating its

behavioral manifestation to its underlying biological organization. In other words, to answer questions related to the mechanisms underlying learning and memory, we must examine the brain directly. In recent years neuroscience has done just that, and we now have some preliminary answers.

By the 1950s neuroscientists realized that the black box of the brain could be opened. The problem of memory storage, once the exclusive province of psychologists and psychoanalysts, had begun to yield to the methods of modern biology. As a result, studies of memory were increasingly designed to translate some of the central unresolved questions in the psychology of learning and memory into the empirical language of biology. The questions now became: What sort of changes does learning produce in the neural networks of the brain? How is memory stored? Once stored, how is memory maintained? What are the molecular steps whereby a transient, short-term memory is converted to an enduring, long-term memory?

The purpose in attempting this translation was not to replace psychological thinking with the logic of molecular biology, but to contribute to the synthesis of psychology and biology and thereby to forge a new science of mind that would do justice to the interplay between the psychology of memory storage and the molecular biology of cell signaling.

WHERE IS MEMORY STORED?

In 1957 the pioneering work of Brenda Milner and her colleagues revealed that certain forms of long-term memory are acquired and encoded by the hippocampus and other regions of the medial temporal lobe, brain structures that are required for conscious awareness. It soon emerged that the brain is capable of forming two major types of memory: explicit (declarative) memory, for facts and events, people, places, and objects; and implicit (nondeclarative) memory, for perceptual and motor skills.

Explicit memory generally requires conscious awareness and relies on the hippocampus, whereas implicit memory does not require conscious awareness and relies mostly on other brain systems: the cerebellum, the striatum,

the amygdala, and, in invertebrate animals, simple reflex pathways themselves. Explicit memories are stored throughout the cortex, whereas implicit memories are stored in a variety of brain regions. Thus we call on the hippocampus when recalling our fondest memories or responding to art, but not when riding a bicycle, because riding a bicycle does not require conscious recall.

HOW IS MEMORY STORED?

Milner's work in the 1970s showed that we have two different types of memory systems, but it was not clear how either of them stores memory. In fact, scientists did not even have a reliable biological context in which to study the mechanism underlying memory storage. At the time, biologists could not distinguish between the two main—and conflicting—theories of memory. One of these, the aggregate field theory, assumed that information is stored in the bioelectric field generated by the average activity of many nerve cells, or neurons. The other, the cellular connectionist theory, posited that memory is stored as an anatomical change in the strength of synaptic connections, the contact points where one neuron communicates with another. The latter theory was derived from the ideas of Santiago Ramón y Cajal, the great Spanish pioneer who was the first person to study the cellular functioning of the brain (Cajal 1894).

It soon became clear that a promising way to distinguish between these disparate theories of memory storage was to take a reductionist approach with a simple animal, which would have so few neurons that nearly all of their interconnections and interactions could be identified. Scientists could then examine the interactions of the individual neurons involved in a simple behavior to see how those interactions were changed by learning and memory storage.

Although reductionist approaches were traditional in many areas of biology, investigators were generally reluctant to consider a reductionist strategy when it came to mental processes such as learning and memory. Yet it was

clear that memory storage is so important for survival that its mechanisms are very likely conserved. (A conserved biological process is one that proved so useful in primitive organisms that it has persisted, through evolution, in animals of increasing complexity.) Thus, a molecular analysis of learning, no matter how simple the animal or the task, was likely to reveal universal mechanisms of memory storage.

One animal that seemed almost ideal for a radical reductionist analysis of learning and memory was the large sea snail *Aplysia* (fig. 4.1, left; Kandel 2001). Indeed, the advantages of the snail for a reductionist analysis had been appreciated by Henri Matisse almost a decade earlier. Toward the end of his career, Matisse realized that he could reconstruct the basic visual elements of a snail with only twelve simple blocks of color, which he cut out of paper (fig. 4.1, right). The purity of color that characterizes Matisse's last, and perhaps greatest, period has been said by the art historian Olivier Berggruen "to induce in the viewer a feeling of freedom, of liberation from all

4.1 *Left*: The marine snail (*Aplysia*); *right*: Henri Matisse, *The Snail*, 1953

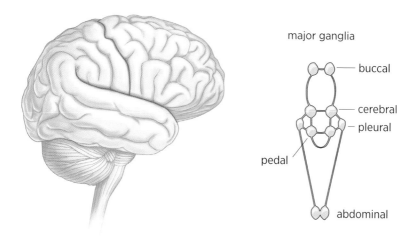

4.2 Comparison of the human brain (*left*) and *Aplysia* brain (*right*). The human brain is numerically complex (100 billion neurons), while the brain of *Aplysia* is simple (20,000 neurons).

that is material" (Berggruen 2003). The colored surfaces capture both the essential form and, with some imagination on the beholder's part, the movement of the snail.

Aplysia's various behaviors—orienting, feeding, mating, crawling, and defensive withdrawal—are controlled by a very simple nervous system made up of relatively few neurons. While the human brain has 100 billion neurons, *Aplysia* has only 20,000 (fig. 4.2). These neurons are distributed in ten clusters called ganglia, each of which contains about 2,000 cells and controls a family of behaviors. As a result, certain simple behaviors may involve fewer than 100 neurons. This numerical simplicity makes it possible to identify precisely an individual cell's contribution to a given behavior. Scientists therefore set out to delineate in this simple animal the simplest possible behavior: the gill-withdrawal reflex (Kandel 2001; Squire and Kandel 2000).

Aplysia has an external respiratory organ called the gill, which is covered by a protective sheath known as the mantle shelf. The mantle shelf contains

the animal's residual shell, which ends in a fleshy spout called the siphon. In response to a light touch on its siphon, *Aplysia* withdraws its gill. The withdrawal is a defensive reflex, much like pulling your hand back from a hot object (fig. 4.3). This elemental response is mediated by a very small number of neurons and can be modified by several forms of learning, including classical (Pavlovian) conditioning. This form of associative learning is recruited unconsciously in our brain when we look at a painting and implicitly relate it to other paintings we have encountered or to relevant personal experiences.

Studying the connections among the neurons involved in the gill-withdrawal reflex—that is, the neural circuitry of the reflex (fig. 4.4)—proved a relatively simple matter. The reflex involves 24 sensory neurons that connect to six motor neurons, both directly and through interneurons (Kandel 2001).

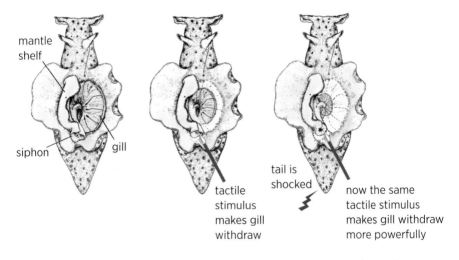

4.3 *Aplysia's* gill-withdrawal reflex can be modified by learning. A weak tactile stimulus to the siphon normally causes the gill to withdraw modestly (middle panel). A shock to the tail scares the animal so that the same weak stimulus to the siphon now produces a much more powerful withdrawal of the gill (right panel). The animal remembers the fear induced by the tail shock as a function of the number of training trials: one tail shock leads to a memory that lasts for minutes, whereas five tail shocks produce a memory that persists for days or weeks.

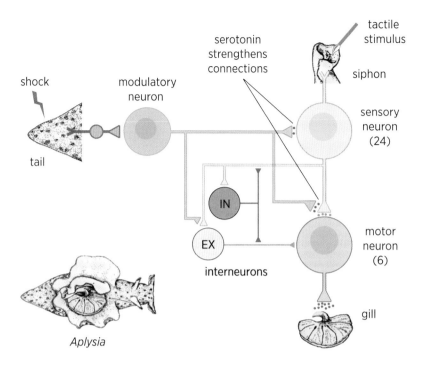

4.4 Neural circuit of the gill-withdrawal reflex. Shocks to the tail strengthen the circuit's connections through the release of serotonin.

Aplysia's neural circuit proved surprisingly invariant. Not only does every animal use the same cells in the reflex circuit, but also those cells are interconnected in precisely the same way in every animal. Each sensory cell and each interneuron connects to a particular set of target cells and to no others. These findings gave us the first insight into a simple example of Kantian *a priori* knowledge. They showed that built into the brain, under genetic and developmental control, is the basic architecture of behavior—in this case, the capability for withdrawal from a noxious stimulus. Subsequently, similar invariance was found in other behaviors of *Aplysia* (Kandel 2001, 2006).

This insight raised a profound question: How can learning occur in such a precisely wired neural circuit? That is, if the neural circuitry of a behavior does not vary, how can that behavior be modified?

THE FORMATION OF SHORT- AND LONG-TERM MEMORY

The solution to this apparent paradox is rather simple: learning changes the strength of the connections among neurons (Castellucci et al. 1978; Hawkins et al. 1983). Even though *Aplysia*'s genetic and developmental program ensures that the connections between cells are correctly specified and invariant, it does not specify the strength of those connections. Thus, much as Locke might have predicted, learning plays upon the basic connections of the neural circuit to form memory. Moreover, persistent alteration in the strength of those connections is the mechanism whereby memory is stored. We see here a reconciliation of nature and nurture, of the Kantian and Lockean points of view, in an elementary and reduced form.

How is memory maintained in the short term and in the long term? To answer these questions, the studies of *Aplysia* focused on several forms of learning, each of which required the snail to modify its behavior in response to different experimental stimulation. Observing how these changes in behavior came about would reveal the mechanisms of learning.

One form of learning used in these studies was classical conditioning. A light touch to *Aplysia*'s siphon causes the animal to withdraw its gill slightly (fig. 4.3). When a light touch to the siphon is followed immediately by a shock to *Aplysia*'s tail, the animal learns that the touch to the siphon *predicts* the shock to the tail. A subsequent light touch to the siphon alone will produce a massive withdrawal of the gill. Thus, in classical conditioning *Aplysia* learns to associate the light touch to the siphon with the shock that follows it.

What are the molecular underpinnings of this form of memory storage? Studies of the synaptic connections between the sensory and motor neurons that control the gill-withdrawal reflex in *Aplysia* revealed that a single stimulus to the tail leads to the activation of modulatory neurons that release serotonin onto the sensory neuron, resulting in an increase in the strength of its synaptic connections with the motor neuron (fig. 4.4). The release of serotonin leads to an increase in the concentration of a signaling

molecule in the sensory cell called cAMP (cyclic adenosine monophosphate). The cAMP molecules signal the sensory neuron to release more of the transmitter glutamate into the synaptic cleft, thus temporarily strengthening the connection between the sensory and motor neurons (Carew et al. 1981, 1983).

In classical conditioning, the light touch to the siphon (the conditioned stimulus) is paired with and applied just before the shock to the tail (the unconditioned stimulus) and produces a greater increase in the gill-withdrawal reflex than either stimulus alone does. How does this come about? The sensory neuron fires an action potential in response to the touch to the siphon, which the animal associates with an imminent shock to its tail. The firing of an action potential increases the amount of cAMP produced by serotonin and thus further strengthens the synaptic connection between the sensory and motor neurons. This more robust connection at the synapse permits a more powerful withdrawal of the gill itself.

The duration of *Aplysia*'s memory of the paired stimuli correlates with the number of training trials. Following a single paired shock, the animal shows a short-term memory of the event, and the reflex is enhanced for a few minutes. After five or more paired shocks, the animal exhibits a long-term memory that lasts for days to weeks. Thus practice makes perfect, even in snails!

How is short-term memory achieved with one training trial, and how is it converted to long-term memory with five trials? Figure 4.5 (left) illustrates a single sensory neuron that receives information from the skin of the siphon and connects directly to a motor neuron in the gill. A single shock to the tail activates the modulatory cells that release serotonin, setting off a chain reaction inside the sensory neuron. The release of serotonin leads to a transient strengthening of the connection between the sensory and motor neuron (fig. 4.5, center). When repeated shocks and repeated release of serotonin are paired with the firing of the sensory neuron in associative learning, a signal is sent to the nucleus of the sensory neuron. This signal activates a gene, CREB-1, which leads to the growth of new

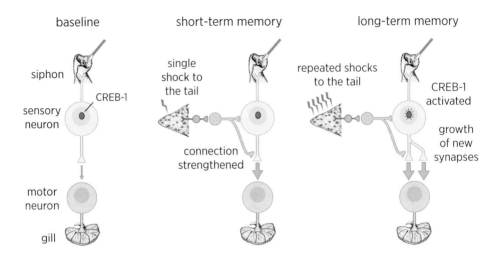

4.5 Different mechanisms underlie short- and long-term memory storage. A single sensory neuron from the siphon skin connects to a motor neuron that innervates the gill. Short-term memory is produced by a single shock to the tail. This activates modulatory neurons (in blue) that cause a functional strengthening of the connections between the sensory and motor neurons. Long-term memory is produced by five repeated shocks to the tail. This activates the modulatory neurons more strongly and leads to the activation of CREB-1 genes and the growth of new synapses.

connections between the sensory and motor neuron (fig. 4.5, right) (Bailey and Chen 1983; Kandel 2001). These connections are what enable a memory to persist. So if you remember anything of what you have read here, it will be because your brain is slightly different than it was before you started to read.

The mechanisms of associative memory formation (classical conditioning) have proven to be very general. They apply to the vertebrate as well as the invertebrate brain and to explicit, or conscious, memory as well as to implicit, or unconscious, memory (Squire and Kandel 2000; Kandel 2001). These processes of associative memory are called upon in the top-down processing that occurs in our brain when we view a work of art (see chapter 8).

MODIFYING THE FUNCTIONAL ARCHITECTURE
OF THE BRAIN

How important is the growth of new connections among neurons in determining the functional architecture of the human brain? How important is it for you and me? And how does it relate to our response to art?

Figure 4.6 depicts the representation of the surface of the human body in the sensory cortex of the brain, with the most sensitive areas—the hands, eyes, and mouth—being the largest. As we have seen, touch is intimately bound up with vision and is an important aspect of our response to art, particularly abstract art.

Until quite recently, it was thought that this representation, this cortical map, was fixed, but we now know it is not. Michael Merzenich of the University of California, San Francisco, found that, as we saw with the growth of new connections in *Aplysia*, the cortical maps of an adult monkey are subject to constant modifications on the basis of use. That is, the cortical map is modified by activity in the pathways leading from the various sense organs to the brain (Merzenich et al. 1988). Leslie Ungerleider has shown similar modifications in the human cortical map (Ungerleider et al. 2002).

The brain's potential for modification appears to vary not only with use but also with age (fig. 4.7). Thomas Elbert and his colleagues at the University of Konstanz in Germany imaged the brains of stringed instrument players and compared them to the brains of nonmusicians (Elbert et al. 1995). The imaging revealed that the representations of the fingers of the musicians' left hands, which move independently, often in highly complicated patterns, are significantly larger than those of nonmusicians. Elbert also observed that even though structural changes can occur in the mature brain, such changes are greater in musicians who began their musical training at an early age. Thus the reason the great violinist and child prodigy Jascha Heifetz became Heifetz was not simply because he had the right genes, but also because he began practicing his musical skills very early in life, when his brain was most sensitive to modification by experience.

4.6 Somatic-sensory homunculus showing the proportional representation of the surface of the skin in the sensory cortex. Areas of greatest sensitivity are most generously represented in the cortical map.

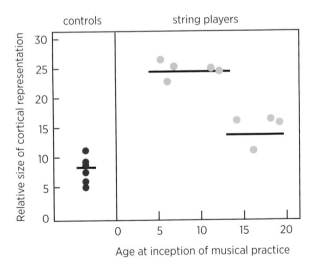

4.7 Comparison of the size of the cortical representation of the fifth finger of the left hand in string players and nonmusicians (controls). Among string players, those who began playing before age thirteen have a larger representation than those who began later. The horizontal lines represent the mean for each group of dots.

These dramatic results confirmed in humans what animal studies had already revealed in greater detail: namely, the proportion of the cortex devoted to the representation of a specific part of the body depends in part on how much or how little those parts are used.

Since all of us are brought up in somewhat different environments, are exposed to different combinations of stimuli, learn different things, and are likely to exercise our motor and perceptual skills in different ways, the architecture of our brains will be modified in unique ways. We each have a slightly different brain because we have different life experiences. Even identical twins, who have identical genes, will have different experiences and therefore different brains. This distinctive modification of brain architecture, along with our distinctive genetic makeup, constitutes the biological basis for the expression of individuality. It also accounts for differences in how we respond to art. As we have seen, our response depends not only on innate, bottom-up perceptual processes in art but also on top-down associations and learning, which are mediated by changes in synaptic strength.

TOP-DOWN PROCESSING AND ART

The reductionist approach to brain science has revealed that learning leads to changes in the strength of connections among neurons. That insight has given us our first clues to *how* aspects of top-down processing occur. In addition, we now know a bit about *where* it occurs: learned visual associations are consolidated in the inferior temporal cortex, a region of the brain that interacts with the hippocampus, which is concerned with the conscious recall of memories. We also understand the basis of our strong emotional response to color and to faces in art: the inferior temporal cortex, which contains specialized regions for processing information about color and about faces, exchanges information with both the hippocampus and the amygdala, which orchestrates emotion.

Emotions—sexuality, aggression, pleasure, fear, and pain—are instinctive processes. They color our lives and help us confront the fundamental

challenges of avoiding pain and seeking pleasure. We shall examine later the interplay of sexuality and aggression in Willem de Kooning's *Woman I* (fig. 7.5) and Gustav Klimt's *Judith* (fig. 7.7). The emotions we bring to bear on a painting are essentially the same as those we bring to bear on everything else in our everyday life. Thus art challenges us to develop new insights into brain science by posing numerous questions about perception and emotion that we are only beginning to appreciate and address. In particular, we are now in a position to begin to explore how different emotional states influence our perception of figurative, as opposed to abstract, art.

While we are just beginning to understand how our brain mediates our perception and enjoyment of art, we do know that our response to abstract art differs significantly from our response to figurative art. And we know why abstract art can be so successful. By reducing images to form, line, color, or light, abstract art relies more heavily on top-down processing—and therefore on our emotions, our imagination, and our creativity. Brain science offers us the potential to develop additional insights into the role of top-down perception in art and into the creativity of the beholder.

Having considered reductionist strategies in biology that pertain to top-down processing, let us now turn to art. Here, reductionist strategies have also been used, consciously or unconsciously, in a variety of different ways.

PART 3

A REDUCTIONIST
APPROACH
TO ART

CHAPTER 5

REDUCTIONISM IN
THE EMERGENCE OF
ABSTRACT ART

M uch as a brain scientist can use reductionism to focus on very
simple cases of learning and memory and to delineate the pro-
cess of visual perception, so an artist can use reductionism to
focus on form, line, color, or light. In its most holistic form, reductionism
allows an artist to move from figuration to abstraction, the absence of figu-
ration. The following chapters consider several examples of artists who have
focused on one or more of these components of art, beginning with J.M.W.
Turner, Claude Monet, Arnold Schoenberg, and Wassily Kandinsky.

TURNER AND THE MOVE TOWARD ABSTRACTION

One of the first artists to use reduction of detail to move from figuration
to abstraction was Joseph Mallord William Turner, one of Britain's greatest
artists (fig. 5.1). Born in 1795, he worked for several architects as a young
man, and many of his early sketches were exercises in architectural perspec-
tive. At the remarkably young age of fourteen he entered the Royal Acad-
emy of Art schools. One year later he was accepted into the Academy. He
began to paint landscapes and seascapes, and is now considered the most

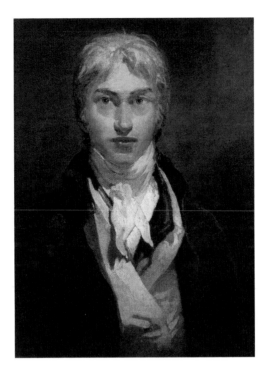

5.1 Joseph Mallord William Turner (1775–1851)

important artist to have elevated landscapes to the same level of importance as historical paintings.

Turner was a master of seascapes, capable of rendering the effects of nature in infinite detail, yet on an epic scale. Early in his career, in 1803, he painted *Calais Pier*. An admirably realistic painting, it depicts several ships on a rough sea, with dramatic use of light, shadow, and perspective and with careful attention to detail: sails strained by the wind, a white seagull against a dark storm cloud. Waves, clouds, the horizon, boats, sails, and people are all clearly represented (fig. 5.2).

Forty years later, in 1842, Turner, then in his late sixties, took on a similar theme in the painting *Snowstorm* (fig. 5.3). Seven years earlier he had toured

the continent, visiting Germany, Denmark, Holland, and Bohemia. A few years after that he had gone to Italy and visited Venice. In each country he studied how light and mist rising from bodies of water affect a visual scene.

In *Snowstorm,* figurative elements are so reduced as to be practically non-existent. Gone are the clearly delineated clouds, sky, and waves; the ship is merely suggested by the line of its mast. The distinction between sea and sky is barely perceptible, yet the viewer senses the towering masses of water, the sweep of wind and rain pounding the ship with terrible ferocity, the powerful, spiraling arrangement of dark and light. By conveying the overwhelming power of movement in nature without the use of clearly defined forms, Turner evokes an even stronger emotional response in *Snowstorm* than he did in *Calais Pier.* The English literary critic, philosopher, and painter William Hazlitt (1778–1830), who greatly admired Turner, referred to his later work as "atmospheric" and "all without form."

At the time Turner was painting the remarkable *Snowstorm,* photography was beginning to revolutionize our ability to capture a view of the world and convert it to a two-dimensional surface. During the Renaissance, Western painting evolved to a progressively more realistic depiction of the world. From Giotto to Gustave Courbet, the skill of the artist was generally measured by the ability to create an illusion of reality: that is, by the ability to convey the three-dimensional world on a two-dimensional canvas.

In 1877 a photograph of a galloping horse—which showed all four of its hooves off the ground for a split second—presented the viewer with a depiction of reality that painting was hard put to match. As a result, a dialogue emerged between the two art forms, and painting lost what Ernst Gombrich called its "unique ethological niche" in the world of depiction. This prompted a search for alternative niches, one of which was greater abstraction.

Meanwhile, Albert Einstein's theory of relativity, first published in 1905, was beginning to be discussed in the public media. The theory challenged absolute notions of space and time, and it eventually had a strong impact on public thinking. For one thing, it encouraged artists to question the classical view of figurative art. Since reality may no longer be as clear-cut as it

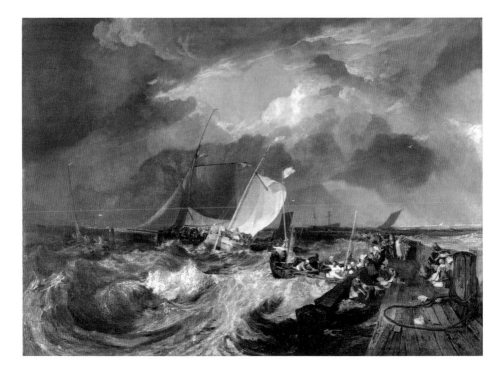

5.2 J.M.W. Turner, *Calais Pier: An English Packet Arriving*, 1803

seems, why does painting need to be a literal depiction of the world? Do we need to depict nature realistically in order to express ourselves? Creators of music, an extraordinary art form that moves us powerfully, do not feel compelled to replicate sounds heard in nature. This self-questioning ultimately led to experiments designed to enlarge the viewer's experience in ways that nineteenth-century photography (and painting) could not.

Turner was one of the first artists to free painting from the "dreary chore of mimesis," and he did so substantially before the theory of relativity was published. Turner achieved this autonomy by handling paint in a new way: using more transparent oils and using color to create a shimmering effect to evoke an almost pure light. Both techniques enhanced his move toward

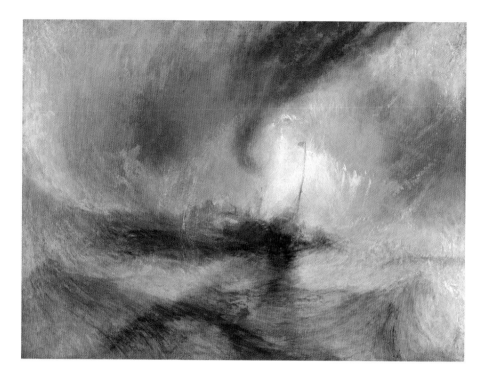

5.3 J.M.W. Turner, *Snowstorm: Steamboat Off a Harbour's Mouth,* 1842

abstraction. Importantly, Turner's work shows that removing figurative elements from a painting does not remove the painting's ability to recruit associations in the mind of the beholder. In fact, as we shall see, abstract art's ability to recruit associations contributes to its power.

MONET AND IMPRESSIONISM

Somewhat later in the progression from figuration to abstraction, the French painter Claude Monet (fig. 5.4) effected a similar reduction in complexity. Early in his career Monet painted a series of figurative images featuring

5.4 Claude Monet (1840–1926)

luncheons in the park, such as *Le Déjeuner sur l'Herbe* (*Luncheon on the Grass*) of 1865 (fig. 5.5). These paintings both challenged and complement-ed Édouard Manet's earlier painting of the same name. In the Manet paint-ing, a nude woman was having a casual lunch in the park with two fully clothed men. Manet meant the painting to be liberating and defiant, but many viewers found it simply shocking.

Monet's paintings were more conventional than Manet's, but they were nevertheless remarkable in the way that they captured the movements of the participants. In *Le Déjeuner* of 1865, Monet depicts a standing woman adjusting her hair beside a man extending his left arm and a seated woman setting out the plates for lunch. The visual continuity between the man's left arm and the left arm of the seated woman causes our eyes to move in

5.5 Claude Monet, *Le Déjeuner sur l'Herbe* (right section), 1865–1866

circles around this large and wonderful painting of a size usually reserved for history paintings.

Between 1870 and 1880, soon after completing these paintings, Monet was joined by Pierre-Auguste Renoir, Alfred Sisley, and Frédéric Bazille. Together they founded a movement of modern painters that also included Camille

5.6 Claude Monet, *Impression, Soleil Levant*, 1872

Pissarro, Paul Cézanne, and Armand Guillaumin. This group emphasized painting outdoors and capturing the changing qualities of light during the course of a day, using pure color, blurring contours, and flattening the image—three early steps toward the emergence of abstraction. The term *Impressionism*, derived from Monet's painting *Impression, Soleil Levant (Sunrise)* (fig. 5.6), was used to describe the movement. The term conveys the effect of a natural scene on the painter and the effect of the painting on the beholder.

Impression, Soleil Levant is a hazy scene of sunrise on the port of Le Havre depicted with loose brushstrokes that are designed to give the beholder a sense of the scene rather than a faithfully realistic depiction. Louis Leroy, a

critic for a Parisian newspaper, commented sarcastically on the unfinished quality of the work: "Wallpaper in its embryonic state is more finished than that seascape" (Rewald 1973). Influenced in part by Turner, Monet and the other Impressionists constructed their paintings from freely brushed color rather than from lines and contours. As a result, Impressionist art in general greatly influenced the emergence of abstract art.

Monet went on to create several other "series" paintings, depicting haystacks and cathedrals at various times of the day, to illustrate how a figurative image changes with different conditions of light. He used a limited palette of new, synthetic oil paints straight out of a tube and mixed the colors on the canvas.

In 1896 Monet began to develop cataracts, which compromised his vision. It was in this context that he painted his last series, 250 oil paintings of water lilies, for which he is best known. These works were painted between 1890 and 1920 at his home in Giverny, where he had constructed a Japanese wooden bridge and a water lily garden. Over time, the paintings began to take on progressively more abstract elements (fig. 5.7), thus encouraging contemplative viewing and study. Although we do not know whether Monet's visual impairment affected his painting, it may very well have led to his reduction of detail. In 1923 he wrote to his friend Berheim-Jeune: "My poor eyesight makes me see everything in a complete fog. It's very beautiful all the same."

On November 12, 1918, the day after the armistice ending World War I was signed, Monet committed to giving the French government a set of large paintings as "a monument to peace." Shortly after his death, in 1926 at the age of eighty-six, the French government constructed two oval galleries at the Musée de l'Orangerie, near the Louvre in Paris, as a permanent home for eight water lily murals.

The galleries, which have seats for viewing and contemplation, are almost invariably filled with people who are entranced by the broad brushstrokes, bright colors, and rich texture of these works. Most of the murals do not show the sky, only the infinity of the lily pond. These remarkable works are

5.7 Claude Monet, *The Water Lily Pond (Nymphéas)*, 1904

filled with ambiguity and beauty. We see in them the beginnings of a change from a dialogue between the artist and his subject to a dialogue between the artist and the canvas. We shall return to this dialogue when we meet Jackson Pollock.

In Monet's paintings, as in Turner's, we see that the movement toward abstraction has a magic of its own, and that it can be more inspiring than figurative art.

SCHOENBERG, KANDINSKY, AND THE FIRST
TRULY ABSTRACT IMAGES

As artists started to move toward abstraction, they began to see analogies between their art and music. Although music has no content and uses abstract elements of sound and division of time, it moves us powerfully. Why, then, does pictorial art have to have content? This question was addressed by the French poet Charles Baudelaire, who pioneered a new style of prose-poetry and wrote the famous volume of poetry *Les Fleurs du Mal* (*The Flowers of Evil*), in which he described the changing nature of beauty in modern life. Baudelaire argued that even though each of our senses responds to a restricted range of stimuli, all of the senses are connected at a deeper aesthetic level. It is therefore particularly interesting that the earliest truly abstract painting was achieved by the pioneer of abstract music, Arnold Schoenberg.

An often-repeated episode in the history of modern art has it that Wassily Kandinsky (1866–1944), the Russian painter and art theorist, tried to abandon figurative painting but could not succeed completely until January 1, 1911. On that date he attended a New Year's concert in Munich and heard for the first time Schoenberg's *Second String Quartet*, composed in 1906, and *Three Piano Pieces, Op. 11*, composed in 1909. Best known as the composer who founded the Second Vienna School of Music, Schoenberg (1874–1951) introduced a new conception of harmony that had no central key, only changes in timbre and tone.

This revolutionary form of composition, referred to as *atonality*, electrified Kandinsky. It showed him that one could reject an artistic convention—the idea of a central key in classical music—and create a more abstract approach. Kandinsky then proceeded to break free of the painterly convention of representing nature and abandoned the last vestiges of figuration. In *Murnau with Church 1* (fig. 5.8) he uses bright colors, but the outlines of the church have become obscure. In 1911 he created *Sketch for Composition V* (fig. 5.9), a work that makes no reference to nature—until then, the central focus of art—or to any recognizable object. It is commonly considered the first abstract painting, a historic work in the canon of Western art.

5.8 Wassily Kandinsky, *Murnau with Church 1*, 1910

© Artists Rights Society (ARS), New York

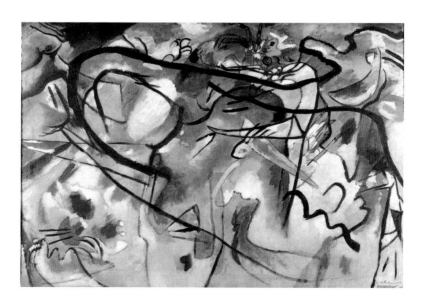

5.9 Wassily Kandinsky, *Sketch for Composition V*, 1911

© Artists Rights Society (ARS), New York

Kandinsky's embrace of abstraction by no means lessens the magic of his paintings or the involvement of the viewer. In fact, the abstract elements of *Sketch for Composition V* present a greater challenge to the viewer's eye and mind, and place greater demands on the viewer's imagination, than do the figurative elements of *Murnau with Church 1*.

Two major styles of visual art influenced Kandinsky: Impressionism and Cubism. The Impressionists realized that they need not represent exactly what they saw; instead, they conveyed what they felt, their state of mind. This realization was carried a step further by the Cubists, beginning with Fernand Léger's *Nudes in the Forest* (1909) and Georges Braque's *Still Life with Metronome* (1909) (Braun and Rabinow 2014). Léger and Braque, like Cézanne, eliminated perspective from their paintings and often depicted the same image from different vantage points. As the conceptual pioneer of abstraction, Kandinsky was the first artist to express abstract forms in colors, signs, and symbols. He realized intuitively that the beholder associates signs, symbols, and colors with images, ideas, events, and emotions recalled from memory.

Inspired by Cézanne's work and that of the Cubists, Kandinsky wrote an extraordinarily prescient treatise in 1910 entitled *Concerning the Spiritual in Art*. He followed this in 1926 with a second book, *Point and Line to Plane*. In these books he points out that painters can make elements of art more objective by emphasizing line, color, and light, thus helping to systematize abstraction. Moreover, his writings provided a philosophical underpinning for abstraction. Kandinsky argued that, like music, art need not represent objects: the sublime aspects of the human spirit and soul can only be expressed through abstraction. Just as music moves the heart of the listener, so form and color in painting should move the heart of the beholder.

A less well-known fact in the annals of abstraction is that Schoenberg, the great innovator in music, had actually accomplished an innovation in abstract painting a year earlier than Kandinsky (Kallir 1984; Kandel 2012). While other pioneers, such as Kandinsky, approached abstraction through landscapes, Schoenberg, a talented and original painter, reached abstraction

through portraiture, a means not seen again until the mid-twentieth century, in the work of Willem de Kooning.

Schoenberg began painting in 1909 with an Expressionist self-portrait (fig. 5.10) and rapidly moved on to more abstract versions, which he called "visions" (figs. 5.11–5.13). His 1910 paintings *Red Gaze* (fig. 5.12) and *Thinking* (fig. 5.13) challenge the viewer to interpret his intention, an interpretation that must depend heavily on the viewer's own imagination. This reductionist approach became even more abstract and systematic in the work of Piet Mondrian, de Kooning, Pollock, Mark Rothko, and Morris Louis, whose paintings are more, rather than less, interesting in their engagement with the beholder.

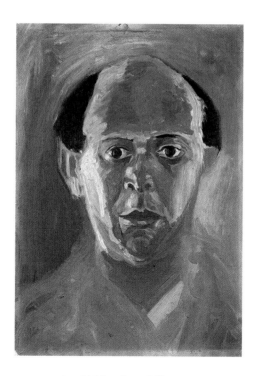

5.10 Arnold Schoenberg, Self-portrait 1910

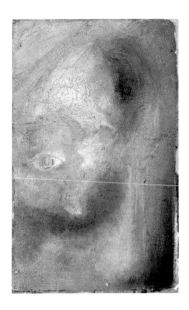

5.11 Arnold Schoenberg, *Gaze*, ca. 1910

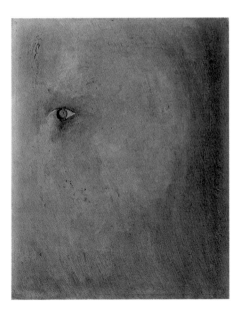

5.12 Arnold Schoenberg, *Red Gaze*, 1910

5.13 Arnold Schoenberg, *Thinking*, ca. 1910

CHAPTER 6

MONDRIAN AND
THE RADICAL REDUCTION OF
THE FIGURATIVE IMAGE

Perhaps the most radical reductionist of the early abstract artists was the Dutch painter Piet Mondrian, the first artist to create an image from pure lines and color. Mondrian entered the Academy of Fine Arts in Amsterdam in 1892, at age twenty. The very next year he held his first exhibition. Mondrian later moved to Paris, but he left in 1938 and, after a brief stay in London, moved to New York in 1940. There he met the artists of the New York School.

Like J.M.W. Turner, Arnold Schoenberg, and Wassily Kandinsky, Mondrian (fig. 6.1) began as a figurative painter. Influenced by Vincent van Gogh, Holland's most famous modern painter, Mondrian painted landscapes, farms, and windmills. His skill is evident in superb early paintings such as *Windmill in the Gein,* painted in 1907, and *Woods Near Oele,* painted in 1908 (figs. 6.2, 6.3).

In 1911, after seeing an exhibition of Cubist works by Pablo Picasso and Georges Braque in Amsterdam, Mondrian moved to Paris. There, he began painting in an analytic Cubist style (Blotkamp 1944). Like Picasso and Braque, Mondrian explored the influential ideas of Paul Cézanne, who greatly influenced the analytic Cubists with his idea that all natural forms can be reduced to three figural primitives: the cube, the cone, and the sphere (Loran 2006; Kandel 2014). Mondrian recognized the plastic elements in

6.1 Piet Mondrian (1872–1944)

6.2 Piet Mondrian, *Oostzijdse Mill with Panoramic Sunset and Brightly Reflected Colors*, 1907-08, Oil on canvas, 99 x 120 cm (39 x 47 1/4")

6.3 Piet Mondrian, *Bosch (woods): Woods Near Oele*, 1908,
Oil on canvas, 128 x 158 cm (50 3/8 x 62 1/8 ")

analytic Cubism, and he began to echo the Cubists' use of geometric shapes
and interlocking planes. He reduced a specific object, such as a tree, to a few
lines and then connected those lines to the surrounding space (fig. 6.4), thus
entangling the branches of the tree with its surroundings. Yet whereas Cub-
ist works played with simple shapes in a complex arena of shattered space,
Mondrian's art became more reductionist. He distilled figures to their most
elemental forms, eliminating altogether the sense of perspective.

In his search for universal aspects of form, Mondrian developed com-
pletely nonrepresentational pictures composed of straight lines and mini-
mal color (fig. 6.5). In this way he succeeded in systematically developing a

6.4 Piet Mondrian, *Tree*, 1912,
Oil on Canvas, 75 x 111.5 cm (29 1/2 x 43 7/8 ")

new language of art based on simple geometric forms that have a meaning of their own, without reference to specific forms in nature. Paradoxically, Mondrian used this reductionist approach to preserve what he considered to be the essence of the mystical energy that governs nature and the universe. In constructing his perception of the essence of an image and freeing it from content, he enables the viewer to construct his or her own perception of the image.

In 1959, brain scientists discovered an important biological basis for Mondrian's reductionist language. David Hubel and Torsten Wiesel, working first at Johns Hopkins University and then at Harvard, discovered that each nerve cell in the primary visual cortex of the brain responds to simple

6.5 Piet Mondrian, *Composition No. II Line and Color*, 1913,
Oil on Canvas, 88 x 115 cm (34 3/4 x 45 1/4 ")

lines and edges with a specific orientation, whether vertical, horizontal, or oblique (fig. 6.6). These lines are the building blocks of form and contour. Eventually, higher regions of the brain assemble these edges and angles into geometric shapes, which in turn become representations of images in the brain.

Zeki describes these physiological findings:

In a sense, our quest and conclusions [are] not unlike those of Mondrian and others. Mondrian thought that the universal form, the constituent of all other, more complex forms, is the straight line; physiologists think that cells that respond specifically to what some artists at least consider

6.6 Neurons in the primary visual cortex respond selectively to line segments that correspond to the specific orientation of their receptive fields. This cell responds most vigorously to a diagonal segment that runs from 10 to 4 o'clock (dashed outline). This selectivity is the first step in the brain's analysis of an object's form.

to be the universal form are the very ones that constitute the building blocks which allow the nervous system to represent more complex forms. I find it difficult to believe that the relationship between the physiology of the visual cortex and the creations of artists is entirely fortuitous. (Zeki 1999, *Inner Vision* 113)

The discovery by Hubel and Wiesel of cells that respond to linear stimuli with specific axes of orientation may partly explain our response to Mondrian's work, but it does not explain the artist's focus on horizontal and vertical lines to the exclusion of oblique lines. Vertical and horizontal lines represented for Mondrian the two opposing life forces: the positive and the negative, the dynamic and the static, the masculine and the feminine. This

reductionist vision is reflected in the evolution of his work. Perhaps Mondrian also implicitly realized that by excluding certain angles and focusing only on others he might pique the beholder's curiosity and imagination about the omissions.

As Charles Gilbert of Rockefeller University has pointed out (personal communication, 2012), it is likely that Mondrian's linear paintings recruit intermediate-level visual processing, which takes place in the primary visual cortex. As we have seen, intermediate-level processing analyzes the shape of objects by determining which surfaces and boundaries belong to them and which belong to the background—the first step in generating a unified visual field (Gilbert 2013a). Mondrian's paintings are also subject to top-down processing, in which we bring to bear on them our experience with other art and other artists.

Lines play a prominent role in the work of many modern artists who followed Mondrian, including Fred Sandback, Barnett Newman, and, to a lesser extent, Ellsworth Kelly and Ad Reinhardt. This emphasis on line does not, in all likelihood, derive from the artists' interest in or knowledge of geometry. Rather, it stems from their efforts, following Cézanne, to reduce the complex forms of the visual world to their essentials and to infer, as the Renaissance artists did with perspective, the essence of form and the rules our brain uses to prescribe form.

In his later work, from the end of the 1920s to his death in 1944, Mondrian applied the same radical reductionist treatment to color. He reduced his palette to the three primary colors—red, yellow, and blue—on a white canvas divided by black vertical and horizontal lines (figs. 6.7, 6.8). In these late paintings, the artist's reduction of form and color creates a sense of movement. This is perhaps most evident in *Broadway Boogie Woogie* (fig. 6.8). Looking at this painting, we can almost feel the boogie woogie beat; our eyes are forced to move around the canvas from one red, blue, or yellow color block to another. As Roberta Smith has pointed out (2015), the pulsating quality of Mondrian's color painting—its totality—presages the constant sense of surprise and movement we encounter in Jackson Pollock's drip paintings.

6.7 Piet Mondrian, *Composition No. III, with Red, Blue, Yellow, and Black*, 1929
Oil on canvas, 50 x 50.5 cm (19 5/8 x 19 7/8 ")

Although he continued periodically to paint figurative works, Mondrian felt that using basic forms and colors enabled him to express his ideal of the universal harmony inherent in all of the arts. He believed that his spiritual vision of modern art would transcend divisions in culture and become a common international language based on pure primary colors, flatness of form, and the dynamic tension in his canvas.

By the early 1920s Mondrian had fused his art and his spiritual interests into a theory (published as "Neo-Plasticism in Pictorial Art") that signaled a complete break with representational painting. His description of his work could serve as a general manifesto for reductionist approaches in art:

I construct lines and color combinations on a flat surface, in order to express general beauty with the utmost awareness. Nature (or, that which I see) inspires me, puts me, as with any painter, in an emotional state so that an urge comes about to make something, but I want to come as close as possible to the truth and abstract everything from that, until I reach the foundation (still just an external foundation!) of things. (Mondrian 1914)

6.8 Piet Mondrian, *Broadway Boogie Woogie*, 1942-1943
Oil on canvas, 127 x 127 cm (50 x 50")

CHAPTER 7

THE NEW YORK SCHOOL
OF PAINTERS

T he artists of the New York School were stylistically diverse, but they shared an interest in developing a new form of abstraction and using it to create art with a strong emotional and expressive impact on the beholder. Many of the artists were inspired by the Surrealist ideal that art should come from the unconscious mind.

Leading the way toward this new art—Abstract Expressionism—were Willem de Kooning, Jackson Pollock, and Mark Rothko. Although they all largely left figuration behind, each of these artists began as a figurative artist, and each learned a great deal from that experience. In turn, we, as viewers, learn a great deal about the application of reductionist approaches to art by observing how each of these painters forged a path from figuration to abstraction in a distinctive, and often selective, manner.

The art critic Clement Greenberg divided the Abstract Expressionist painters into two groups (1961, 1962): the gestural painters de Kooning and Pollock, and the color-field painters Rothko, Morris Louis, and Barnett Newman. However, as the art historian Robert Rosenblum points out, this distinction is less important than the artists' common pursuit of the sublime (1961).

The gestural painters were highly investigative in their art and in their abandonment of figuration, much as Piet Mondrian was. In that sense,

de Kooning and Pollock were also reductionists. But unlike Mondrian or the color-field painters, de Kooning and Pollock, whose end products are often quite complex, combined their reduction of figuration with a rich painterly background.

DE KOONING AND THE REDUCTION OF FIGURATION

Willem de Kooning (fig. 7.1) was born in Holland in 1904 and settled in the United States in 1926. He received his early artistic training during eight years at the Rotterdam Academy of Fine Arts and Techniques. Thus, unlike the other founders of the New York School, he brought a modern European sensibility to the American scene.

7.1 Willem de Kooning (1904–1997)

© Tony Vaccaro / Archive Photos / Getty Images

7.2 Willem de Kooning, *Seated Woman*, 1940

In 1940 de Kooning began painting figurative forms, mostly of women, that combined both Expressionist and abstract tendencies, as evident in *Seated Woman* (fig. 7.2). In the late 1940s and early 1950s his work became more abstract, and he reduced the female figure—an enduring focus of his artistic imagination—to abstract geometric forms, as in *Pink Angels* (fig. 7.3).

7.3 Willem de Kooning, *Pink Angels*, c. 1945,
Oil and charcoal on canvas, 52 x 40 in. (132.1 x 101.6 cm)

Two of de Kooning's paintings were of seminal importance in this pe-
riod: *Excavation* (fig. 7.4) and *Woman I* (fig. 7.5). *Excavation*, painted in
1950, is generally considered one of the most important paintings of the
twentieth century. Mark Stevens and Annalyn Swan (2004), biographers of
de Kooning, say that he was caught up in the excitement of the American
century and felt he needed to seize the day. They write:

Excavation was first and foremost an excavation of desire. The body was
always turning up in the paint, evocatively, but could never be held for

long in the eye: the flesh could never be entirely possessed. Any more settled description of the body would have diminished the sensation of physical movement, such as the caress of the hand or a leap of the heart, that was also a vital part of desire.

For decades in Europe, the art of painting had fluctuated between classical reserve and Expressionist impulses, between the rational and the irrational. In particular, it seesawed between Cubism and Surrealism. In de Kooning's circle, Cubism represented not only a certain way of organizing space but also a responsibility to make a well-constructed picture. De Kooning was keenly aware of his European heritage, and as a painter he was sensitive to the accomplishments of both the Cubists and the Surrealists. The Cubists represented a tradition that went back to Cézanne, while the Surrealists found their authority in private dreams rather than adherence to the past.

In *Excavation*, de Kooning achieved a magisterial synthesis of these two modern claims on truth. His powerful, poised style integrated the rigorous detachment of Cubist structure with the personal drive and spontaneity of Surrealism. Few paintings in the history of art convey such respect for history, order, and tradition while celebrating the spontaneity of the moment. Moreover, as Pepe Karmel has pointed out (personal communication), in *Excavation* de Kooning has multiplied and repeated shapes so that they form a consistent, all-over pattern of texture, abolishing the distinction between figure and ground that we see in *Pink Angels.*

De Kooning gave the synthesis of Cubism and Surrealism a strong American character. *Excavation* is brash and pulsating: with the possible exception of Mondrian's *Broadway Boogie Woogie* (fig. 6.8), no other painting conveys with comparable force the jazzy syncopation of the city. The rhythmic lines lead the viewer's eye through the painting at different speeds, with the constant stop-start, quick turn, and sudden open spaces of the hooking stroke and the passing glimpses of figurative forms. Color slips beguilingly across our eyes and is lost. *Excavation* is a personal improvisation on the great abstract way of modern life in New York City.

7.4 Willem de Kooning, *Excavation*, 1950

In his second important painting of the early 1950s, *Woman I* (fig. 7.5), de Kooning went in a new figurative direction, depicting a vampish, buxom woman embedded in abstraction. *Woman I* is clearly designed to be a contemporary American woman, with her toothy smile, high heels, and yellow dress; she is apparently based, at least in part, on Marilyn Monroe (Gray 1984; also see Stevens and Swan 2005). *Woman 1* caused a sensation that, according to the art historian Werner Spies (2011, 8:68), could only be compared to the scandal surrounding Manet's *Olympia*, a painting that

7.5 Willem de Kooning, *Woman I*, 1950–1952

challenged the social standards of his time by presenting not an idealized woman, but a sexually available woman who confronts the viewer directly.

Woman I is considered to this day to be one of the most anxiety-producing and disturbing images of a woman in the history of art. In this painting de Kooning, who was reared by an abusive mother, creates an image that captures the divergent dimensions of the eternal woman: fertility, motherhood, aggressive sexual power, and savagery. She is at once a primitive earth mother and a femme fatale. With this image, marked by fanglike teeth and

7.6 The first known female sculpture, the Venus of Hohle Fels, circa 35,000 B.C.

huge eyes that echo the shape of her enormous breasts, de Kooning gave birth to a new synthesis of the female.

It is interesting to compare *Woman I* to the oldest surviving example of a fertility sculpture (fig. 7.6) and to Klimt's modern view of female eroticism (fig. 7.7). The Venus of Hohle Fels, thought to be a fertility goddess, was carved in about 35,000 B.C.E. from a mammoth tusk. She is faceless, and she represents a rather crude exaggeration of the female figure: her vulva, breasts, and belly are pronounced, suggesting a strong connection to fertility and pregnancy. We see some of these exaggerated elements in *Woman I*, but the Venus of Hohle Fels lacks the aggression and savagery of the de Kooning painting.

The fusion of eroticism and aggression appears later in Western art. We see it clearly in Gustav Klimt's seductive, beautiful *Judith*, painted in 1901 (fig. 7.7). Klimt portrays the Jewish heroine fondling Holofernes' head in a postcoital trance, having first plied the Assyrian general with drink, seduced

7.7 Gustav Klimt, *Judith*, 1901

© Belvedere, Vienna

him, and then decapitated him in order to save her people from the siege he had laid upon them. In his overall body of work, Klimt shows that women, like men, experience a range of sexual emotions, from eroticism to aggression, and illustrates that these emotions are often fused. Despite their differences, both *Judith* and *Woman I* display considerable sexual power, and remarkably, each woman is depicted showing her teeth.

Today, brain scientists are examining the fusion of aggression and sex that Klimt and de Kooning depicted. In his studies of the neurobiology of emotional behavior, David Anderson at the California Institute of Technology has found some of the biological underpinnings of these conflicting emotional states (fig. 7.8).

We have seen that the region of our brain known as the amygdala orchestrates emotion and that it communicates with the hypothalamus, the region that houses the nerve cells that control instinctive behavior such as parenting, feeding, mating, fear, and fighting (chapter 3, fig. 3.5). Anderson found a nucleus, or cluster of neurons, within the hypothalamus that contains two distinct populations of neurons: one that regulates aggression and one that regulates mating (fig. 7.8). About 20 percent of the neurons located on the border between the two populations can be active during either mating or aggression. This suggests that the brain circuits regulating these two behaviors are intimately linked.

How can two mutually exclusive behaviors—mating and fighting—be mediated by the same population of neurons? Anderson found that the difference hinges on the intensity of the stimulus applied. Weak sensory stimulation, such as foreplay, activates mating, whereas stronger stimulation, such as danger, activates aggression.

In 1952 Meyer Schapiro paid a visit to de Kooning's studio, where he says he found the artist distraught over *Woman I*. De Kooning had abandoned the painting after having worked on it for a year and a half. When he pulled it out from under the couch and showed it to Schapiro, the art historian admired it greatly and discussed it in a wide-ranging way that made de Kooning aware of its power. De Kooning concluded not only that the picture was finished but also that it was a masterpiece (Solomon 1994). Peter Schjeldahl, an art critic at *The New Yorker* who considered de Kooning the greatest American painter and, after Pablo Picasso and Henri Matisse, the greatest of all twentieth-century artists, referred to Shapiro's visit as "history's luckiest studio visit" (Zilczer 2014).

Some art critics, including Greenberg, who thought de Kooning had reached new heights with *Excavation* believed that the artist had betrayed

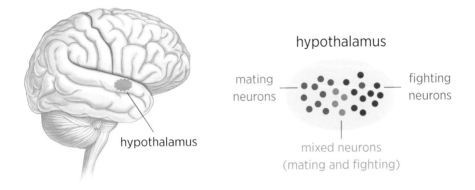

7.8 The hypothalamus contains two groups of contiguous neurons, one group that regulates aggression (fighting) and one that regulates mating. Some neurons at the borders of the two populations (mixed neurons) can activate either behavior (based on data from Anderson 2012).

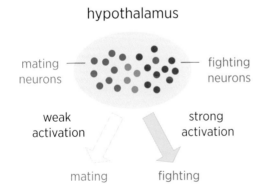

7.9 The intensity of a stimulus determines which neurons are activated and the resulting behavior of the animal.

abstraction by reverting to a figurative form in *Woman I*. In fact, de Kooning was unique among the New York School painters in moving freely from figuration to abstract reductionism and back again, often incorporating both techniques into a single painting. By the 1970s, however, most of de Kooning's work was fully abstract.

While some art critics thought *Woman I* revealed a misogynist perspective, others, including Spies, saw it and de Kooning's other paintings of women in the 1950s as representing the archetypal woman: at once primitive, exotic, procreative, and aggressive. For these reasons, *Woman I* can be considered a visual metaphor for the Abstract Expressionists' goal of creating a new world from the chaos and destruction of the old.

De Kooning's work was enthusiastically supported by Rosenberg, who saw the canvas as an arena for action. From his perspective, the Abstract Expressionism of the New York School represented a rupture, a discontinuity in modern art. Greenberg, on the other hand, saw *Woman I* as one of the most advanced paintings of the time, in part because de Kooning had invested it with the power of sculptural contours derived from the human form. Greenberg therefore saw *Woman I* as part of a great tradition of craftsmanship that includes artists like da Vinci, Michelangelo, Raphael, Ingres, and Picasso (Zilczer 2014).

Under the influence of Chaim Soutine (1893–1943), a Russian-born Jewish Expressionist painter who worked in Paris, de Kooning began to add texture to his abstract paintings, giving the surfaces a richer material appearance and a sculptural quality that evokes a tactile sensibility in the beholder. This tactile quality, which is evident in *Woman I* and even more so in later paintings such as *Two Trees on Mary Street . . . Amen!* (fig. 7.10) and *Untitled X* (fig. 7.11), creates an additional source of light, a glow that comes from within the painting. It also illustrates the particular emphasis that abstract art places on texture as well as color. The art historian Arthur Danto (2001) quotes de Kooning as saying—following Titian—that "flesh was the reason oil paint was developed."

Despite the abstract nature of these paintings, de Kooning later insisted that he was not interested in "abstracting"—taking things out and reducing

7.10 Willem de Kooning, *Two Trees on Mary Street . . . Amen!*, 1975

his paintings to form, line, or color. Rather, he often painted in what appeared to others to be an abstract form because the reduction of figuration allowed him to put more emotional and conceptual components into the painting: anger, pain, love, his ideas about space.

De Kooning also created a new compositional device, a variation on the action painting first developed by Pollock. As is evident in the white streaks in *Untitled X* (fig. 7.11), de Kooning varied the "visual" speed of his brush, thus masterfully leading the eye first at one speed and then another. All of these devices are devoid of figurative elements, but they are richly evocative,

7.11 Willem de Kooning, *Untitled X*, 1976

encouraging the viewer's eye and mind to explore the surface of the canvas, to feel its textures, and to engage in the provocative play of foreground and background.

In evaluating the viewer's response to texture in art, art historians have often underestimated the brain's ability to coordinate the information it receives from different senses. Vision and touch are particularly interrelated, as we have seen. Bernard Berenson was perhaps the first art historian to argue that "the essential in the art of painting [is] . . . to stimulate our consciousness of tactile values" and thus to appeal through texture and edges to

our tactile imagination as strongly as the actual three-dimensional object being depicted would (Berenson 1909). He goes on to say that the reduced elements of form—volume, bulk, and texture—are principal elements of our aesthetic enjoyment of art. Berenson was referring to the creation of tactile sensibility through illusions, such as shading and foreshortening. When we view a painting by de Kooning or Soutine, however, our visual sensations are translated into sensations of touch, pressure, and grasp by the three-dimensional surface of the paint itself (see also Hinojosa 2009). Thus abstraction of a visual element, combined with its tactile appeal, can enrich our aesthetic response even further.

POLLOCK AND THE DECONSTRUCTION
OF THE EASEL PAINTING

De Kooning, more than any other American artist of the twentieth century, altered the vocabulary of painting and even the notion of what painting is about (Spies 2010). But because he never completely abandoned figuration, it was Pollock who, according even to de Kooning, "really broke the ice." Pollock proved to be, by far, the strongest personality of his generation. As de Kooning put it: "Every so often, a painter has to destroy painting. Cézanne did it. Picasso did it with cubism. Then Pollock did it. He busted our idea of a picture all to hell. Then there could be *new* paintings again" (Galenson 2009).

Jackson Pollock (fig. 7.12) was born in Cody, Wyoming, in 1912. In 1930 he moved to New York City to live with his brother Charles, who was an artist. Pollock soon started to work with Thomas Hart Benton, a leading American regionalist painter who was also his brother's art teacher.

Early in his career Pollock, like Rothko and de Kooning, painted Expressionist figures. Under Benton's influence, his early style featured swirling patterns that bear some resemblance to Turner (fig. 7.13; also see fig. 5.3). But in 1939 Pollock encountered Picasso's work at an exhibition at the Museum of Modern Art in New York. Picasso's artistic experiments with Cubism stimulated Pollock to start experimenting on his own. In this effort

he was also influenced by the Spanish Surrealist painter and sculptor Joan Miró and by the Mexican painter Diego Rivera.

By 1940 Pollock had moved to abstract painting, with only residual figurative elements. This is evident in *The Tea Cup* (fig. 7.14), a painting that abandons perspective and balances figuration and abstraction. The beauty and intrigue of *The Tea Cup* likely stems from the fact that the painting is laden with meaningful symbols (which require top-down visual processing) that also relate meaningfully to each other. The painting is textured, but it has flat areas of color and looping black lines.

Having achieved considerable recognition with these abstract works, Pollock went on between 1947 and 1950 to develop a new method of painting, one that revolutionized abstract art. He took the canvas off the wall and put it on the floor. In doing this, he was following the lead of Native American Indian sand painters in the Southwest, whose traditional works he had become familiar with during his boyhood in Wyoming (Shlain 1993).

7.12 Jackson Pollock (1912–1956) at his Springs studio in East Hampton, New York State, August 23, 1953

© Tony Vaccaro/ Archive Photos / Getty Images

7.13 Jackson Pollock, *Going West*, 1934–35

© 2016 The Pollock-Krasner Foundation/Artists Rights Society (ARS), New York

Abandoning both figuration and the conventional method of painting, Pollack developed a new reductive approach. He poured and dripped paint onto the canvas using not only brushes but also sticks—drawing in space, so to speak. In addition, he moved around the canvas so as to be able to work on every part of it. Finally, Pollock stopped applying names to his paintings and now just gave them numbers, so that the beholders would be free to form their own opinion of the work of art without being biased by the title of the work. This radical approach, which focused on the act of painting, was appropriately called *action painting* (figs. 7.15, 7.16).

The term "action painting," introduced by Rosenberg (1952), conveys the process of creation. Pollock argued that the act of painting has a life of its own, and he tried to let it come through. "On the floor," he stated, "I am more at ease, I feel nearer, more a part of the painting, since this way I can

7.14 Jackson Pollock, *The Tea Cup*, 1946

walk around it, work from the four sides and be literally 'in' the painting" (Karmel 2002). Pollock's action paintings are dynamic and visually complex, and his execution of them required great expenditures of energy.

At first glance, it may be difficult to discern reductive elements in Pollock's extremely complex action paintings, but he in fact made two important reductionist advances. First, he abandoned traditional composition: his works do not have any points of emphasis or identifiable parts. They lack a central motif and encourage our peripheral vision. As a result, our eyes are constantly on the move: our gaze cannot settle or focus on the canvas. This is why we perceive action paintings as vital and dynamic. Second, Pollock's

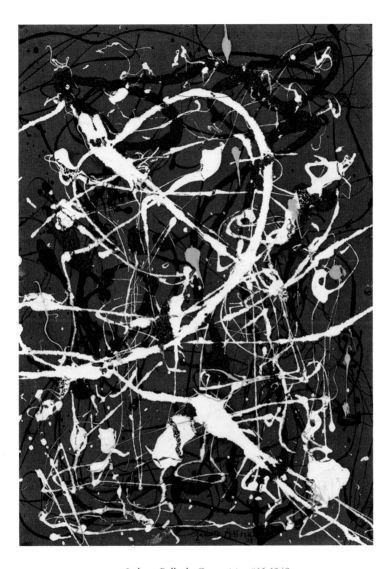

7.15 Jackson Pollock, *Composition #16*, 1948

7.16 Jackson Pollock, *Number 32*, 1950

© The Pollock-Krasner Foundation/Artists Rights Society (ARS), New York

action paintings introduced what Greenberg referred to as a "crisis" in ea-
sel painting: "The easel painting, the movable picture hung on a wall, is a
unique product of the West, with no real counterpart elsewhere. . . . The
easel picture subordinates decorative to dramatic effect. It cuts the illusion
of a box-like cavity into the wall behind it, and within this, as a unity, it
organizes three-dimensional semblances" (Greenberg 1948).

Greenberg went on to argue that the essence of easel painting was first
compromised by Picasso and Alfred Sisley and that artists like Pollock
continued on the path to destroy it. "Since Mondrian," wrote Greenberg,
"no one has driven the easel picture quite so far away from itself." The
dissolution of pictorial images into sheer texture—into apparently pure
sensation—through an accumulation of repetition seemed to Greenberg to
speak to something profound in contemporary sensibility.

Pollock himself saw drip painting as a reductionist approach to art. In abandoning figuration, he felt that he had removed constraints on his unconscious and the creative process. As Freud had pointed out years earlier, the language of the unconscious is governed by "primary process" thinking, which differs from the secondary process thinking of the conscious mind in having no sense of time or space and in readily accepting contradictions and irrationality. Thus, in reducing conscious form to an unconsciously motivated drip-painting technique, Pollock showed remarkable inventiveness and originality. As part of a 1998 retrospective of Pollock's work held by the Museum of Modern Art, Kirk Varnedoe, a curator of the event, wrote: "Pollock has been admired as a great eliminator But, like the best of modern art, it also has tremendous generative, and regenerative, power" (Varnedoe 1999, 245).

Pollock seems to have grasped intuitively that the visual brain is a pattern-recognition device. It specializes in extracting meaningful patterns from the input it receives, even when that input is extremely noisy. This psychological phenomenon is referred to as *pareidolia*, in which a vague, random stimulus is perceived as significant. Da Vinci writes of this capability in his notebooks:

> If you look at any walls spotted with various stains or with a mixture of different kinds of stones, if you are about to invent some scene you will be able to see in it a resemblance to various different landscapes adorned with mountains, rivers, rocks, trees, plains, wide valleys, and various groups of hills. You will also be able to see divers combats and figures in quick movement, and strange expressions of faces, and outlandish costumes, and an infinite number of things which you can then reduce into separate and well-conceived forms. (Da Vinci 1923)

Thus Pollock's work speaks to a profound question: How do we impose order on randomness? This is a question that Kahneman and Tversky explored extensively in their collaborative work (Kahneman and Tversky 1979; Tversky and Kahneman 1992), which led to a Nobel Prize in economics

for Kahneman in 2002 (Tversky died in 1996). They showed that when confronted with a choice that has low probability—approaching random-ness—our top-down cognitive processes impose order on the choice so as to decrease the uncertainty. This is what the beholder of an action painting often does—looks for a pattern in random splatters of paint.

Pollock's intelligence is often described as an intelligence of the body. His first dealer, Betty Parsons, speaks of him in the following terms:

> How hard Jackson could work, and with such grace! I watched him and he was like a dancer. He had the canvas on the floor with cans of paint around the edges that had sticks in them, which he'd seize and—swish and swish again. There was such rhythm in his movement. . . . [His compositions] were so complex, yet he never went overboard—always in perfect balance. . . . The best things in the great painters happen when the artist gets lost . . . something else takes over. When Jackson would get lost, I think the unconscious took over and that's marvelous. (Potter 1985)

By superimposing one layer of paint on another and by applying thick paint squeezed from a tube to his canvas, Pollock succeeded in creating a tactile sensation (fig. 7.16). This sense of texture is heightened by interweaving and overlapping lines of color. In later paintings he also created texture through the use of *impasto,* a technique that consists of applying thick paint with a brush or a paint knife. Because Pollock's brushwork is so agitated, his technique of applying thick impasto over textured surfaces creates an almost three-dimensional, sculptural quality, a technique introduced into art by Vincent van Gogh. In his essay "American Action Painters," Rosenberg wrote that Pollock, by turning painting into a series of actions, had "eliminated the separation between art and life."

CHAPTER 8

HOW THE BRAIN
PROCESSES AND PERCEIVES
ABSTRACT IMAGES

T he reason that figurative art, such as portraiture, can exert such a profound impact on us is that the visual system of our brain has powerful bottom-up machinery for processing scenes, objects, and particularly faces and facial expressions. Moreover, we respond more strongly to the exaggerated depiction of a face by an Expressionist artist such as Oskar Kokoschka or Egon Schiele because the face cells in our brain are tuned to respond more powerfully to exaggerated facial features than to realistic ones.

How, then, do we respond to abstract art? What machinery in the brain enables us to process and perceive paintings whose images have been radically reduced, if not eliminated? One point that emerges clearly is that many forms of abstract art isolate color, line, form, and light, thus making us implicitly more aware of the functioning of the individual components of the visual pathway.

The idea that has driven much of modern research on the perception of art came from Ernst Kris's insight that each of us perceives a given work of art somewhat differently, so that viewing a work of art involves a creative process on the part of the beholder. As we saw in chapter 3, Ernst Gombrich applied Kris's ideas about ambiguity in art to the entire visual world by focusing on the inverse optics problem.

Each of us takes incomplete information from the outside world and makes it complete in our own distinctive way. The reason we succeed in reconstructing a three-dimensional image from reflected light—and in doing so accurately most of the time—is that our brain provides context not only through bottom-up but also through top-down processing of visual information. As we have seen, bottom-up information is supplied by the computational logic built into the circuitry of the visual system, such as the ability to recognize faces, while top-down information is supplied by cognitive processes such as expectation, attention, and learned associations.

Thomas Albright and Charles Gilbert have recently made substantial progress in understanding top-down processes, especially the learning mechanisms that underlie them. In discussing these processes we must first distinguish between sensation, which is more closely related to bottom-up processing, and perception, which is more closely related to top-down processing.

SENSATION AND PERCEPTION

Sensation is the immediate biological consequence of stimulating a sensory organ, such as the photoreceptors in our eyes. Sensory events can affect our behavior directly, but they lack context. Perception, as we have seen, incorporates the information our brain receives from the external world with knowledge based on learning from earlier experiences and hypothesis testing. Thus, as it pertains to vision, perception is the process whereby reflected light becomes linked to an image in the environment, is made enduring by the brain, and becomes coherent when the brain assigns it meaning, utility, and value.

A critical element in perception is the recruitment of associations between a particular sensory event and other images and other sources of information. These associations provide the context necessary to resolve the ambiguity inherent in all sensations (Albright 2015) and, as Kris noted, the

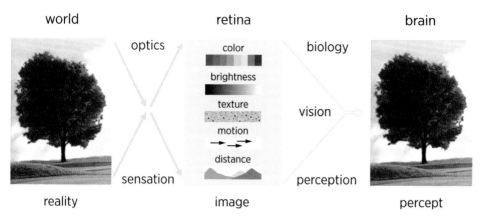

8.1 The central problem of vision is twofold: one component is optical and the other perceptual. The optical problem—the problem of sensation—involves the reflection of light off surfaces in the visual environment, resulting in an image on the retina. The perceptual problem involves identification of the elements of the visual scene that gave rise to the retinal image. This is a classic inverse problem for which there is no unique solution: a given retinal image could be caused by any one of an infinite set of visual scenes.

ambiguity inherent in a work of art. The American philosopher William James draws the distinction between sensation and perception in this way: perception differs from sensation by recruiting the consciousness of further facts associated with the object causing the sensation (James 1890).

The distinction between sensation and perception is the central problem of vision (Albright 2015). Whereas sensation is optical and involves the eyes, perception is integrative and involves the rest of the brain as well (fig. 8.1).

As we have seen, learning and memory include the strengthening of specific synaptic connections in the brain. Albright and Gilbert discovered that top-down processing is the result of a critical computation in which brain cells use contextual information to transform incoming sensory information, such as that from a work of art, into an internal representation, or percept (Albright 2015; Gilbert 2013b).

Where in the brain does the synaptic strengthening that contributes to this top-down processing occur? A significant body of evidence now suggests that one key site for the storage of long-term memories of associations is the inferior temporal cortex, a region with direct connections to the hippocampus (fig. 8.2), where explicit memories of people, places, and objects are encoded.

The inferior temporal cortex represents the pinnacle of the brain's visual information-processing hierarchy and is known to be important for object recognition, which relies on our memory of prior associations. Bottom-up signals sent by sensory neurons in response to objects in our visual field are processed into representations of those objects in the inferior temporal cortex, where, for example, the face patches are located. Learning to associate one object with another is achieved by strengthening the connections between the neurons representing each object; this is done via the indirect pathway (fig. 8.2). The resulting association is consolidated in the inferior temporal cortex and stored by memory structures in the medial temporal lobe.

Albright and his colleagues tested this idea by training monkeys to associate pairs of visual stimuli that consisted of meaningless patterns. As each monkey was learning the association, the scientists monitored the activity of neurons in the monkey's inferior temporal cortex. They found that at the outset, the neurons responded selectively to each object, each visual pattern. As the monkeys began to learn to associate two stimuli, the connections between neurons that initially responded to one or the other visual pattern were strengthened. These changes in the neurons are physical manifestations of classical conditioning, of newly learned association. Memories consolidated in this manner, over the course of a lifetime, provide us with further information that we then associate with a perceived object through the indirect pathway.

The indirect pathway can also be activated by the contents of working memory—that is, by feedback from the prefrontal cortex, which is concerned both with aspects of working memory and with executive functions. Under normal conditions a visual experience results from combined direct and indirect inputs to the inferior temporal cortex. However, we have

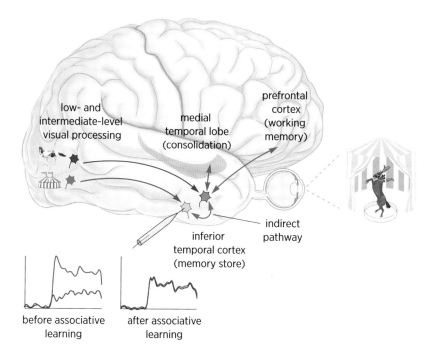

8.2 Circuits for visual association and recall. Bottom-up signals from sensory cells lead to representations of a circus tent and a horse in the inferior temporal cortex. Before associative learning, a neuron (in light blue) responds well to the circus tent but not to the horse. Learned associations between the two objects are consolidated in the inferior temporal cortex by strengthening connections between the neurons representing each of the paired objects via the indirect pathway. Thus, activating the indirect pathway results in recall of the circus tent following presentation of the horse.

reason to believe that the changes in neural connections underlying learned associations are not limited to inputs to the inferior temporal cortex: they reflect a general capability of the entire visual system—in fact, of all sensory systems. Evidence for this idea comes in part from imaging studies of brain activity during learning, which have revealed changes in neuronal activity even in regions where the very early stages of visual processing take place.

This finding led Albright to explore associative learning by examining the response properties of neurons in the medial temporal cortex, which

occupies an intermediate position in visual processing. And, indeed, he found changes in connectivity that are similar to the changes seen in neurons in the inferior temporal cortex.

Alumit Ishai and her colleagues have illustrated this point further (Mechelli et al. 2004; Fairhall and Ishai 2007). When they showed study volunteers actual images of faces or houses, the images activated areas of the visual cortex engaged in the early stages of processing. In contrast, when they asked the volunteers to *recall* the images of faces or houses, two regions of the brain involved in top-down processing were activated: the prefrontal cortex and the superior parietal cortex. The prefrontal cortex responds only to figurative images that the brain can fit into a known category, such as a face or house or cat—images that convey content. The superior parietal cortex, which manipulates and rearranges information in working memory, is activated by any visual image.

These results indicate that sensory representation of faces and objects in the brain is largely mediated by bottom-up processes arising in the early visual areas, whereas perception of images derived from memory storage is mediated in good part by top-down mechanisms originating in the prefrontal cortex (Mechelli et al. 2004).

Thus, when we look at a work of art, information from several sources interacts with the incoming pattern of light to yield our perceptual experience of that work. Much information is conveyed to the brain from bottom-up processing, but important information is also added from our memory of prior encounters with the visual world. These memories of other experiences with other works of art enable us to infer the cause, category, meaning, utility, and value of the images on our retina.

In sum, the reason we can usually resolve the ambiguity of a retinal image accurately because our brain supplies context. Context, broadly speaking, consists of other bits of information: those that are also present in the retinal image; those, such as face processing, that are inherent in the computational machinery of the brain; and finally, those learned from prior experience with the world, including the world of art.

As early as 1644 René Descartes argued that visual signals originating in the eye and those originating from memory are both experienced by the conversion of information onto a common brain structure. This idea has recently been supported by functional brain imaging studies, in which people are asked to imagine specific visual stimuli or are trained to recall an image through association with another image. The studies have documented patterns of activity in a variety of brain regions involved in low- and intermediate-level visual processing.

Similarly, electrophysiological recordings of activity in the inferior temporal cortex of study volunteers show that they respond strongly to pictures. Abstract art, like Impressionist art before it, relies on the assumption that simple, often crudely depicted features are sufficient to trigger a perceptual experience that is then richly completed by the observer. Evidence from brain studies suggests that this perceptual completion occurs through the projection of highly specific top-down signals into the visual cortex.

Thus, what abstract artists contend—and abstract art itself bears out—is that an impression, a sensory stimulation of the retina, is merely a spark for associative recall. The abstract painter does not attempt to provide pictorial detail, but rather to create conditions that enable the viewer to complete the picture based on his or her own unique experience. Legend has it that upon viewing a sunset painted by Turner, a young woman remarked, "I never saw a sunset like that, Mr. Turner," to which Turner replied, "Don't you wish you could, madam?"

The pleasure that many viewers derive from abstract art is an example of what James terms "the victorious assimilation of the new"—the coherent perceptual experience of something we have never quite seen before—by its association with familiar things (James 1890). I would argue further that the assimilation of the new—the recruitment of top-down processes as part of the beholder's creative reconstruction of the image—is inherently pleasurable because it stimulates our creative selves and contributes to the positive experience that many beholders have in the presence of certain works of abstract art.

REVISITING THE ABSTRACT PAINTING
OF DE KOONING AND POLLOCK

A simple example of the importance of the associations we bring to bear on abstract art is illustrated in figures 8.3 and 8.4. Unless we have seen figure 8.4 before, we have difficulty grasping what this apparently random pattern of light and dark regions symbolizes. But our perceptual experience is radically altered when we view figure 8.4, which provides enough information to resolve the ambiguity in the earlier image. Moreover, after we have seen figure 8.4, our next encounter with figure 8.3 will be markedly different because of the information we bring to bear on it from memory. In fact, our perception of the original image may have been permanently altered.

Ramachandran and his colleagues examined the cellular mechanisms underlying this phenomenon (Tovee et al. 1996). They found that the response of single neurons in the inferior and in the medial temporal cortex can change rapidly, showing the effects of learning after as little as five to ten seconds of exposure to the unambiguous image. After this brief exposure, the brain applies that learning to the ambiguous image.

These cellular experiments in monkeys and parallel psychophysical studies in humans illustrate that people and higher primates are capable of rapid learning about stimuli in the visual world. This may be why we can recognize faces and objects that we have seen for only a few seconds. These findings are also consistent with Albright's and Ishai's discovery that neurons in the inferior and medial temporal cortex are part of a top-down processing system that includes the prefrontal cortex and the superior parietal cortex.

With this example of associations in mind, let us reexamine de Kooning's and Pollock's transition from figuration to abstraction.

De Kooning's *Seated Woman*, painted in 1940 (fig. 8.5), is a depiction of Elaine Fried, whom he would marry three years later. This was one of de Kooning's first paintings of a woman, and it already contains some fascinating abstract touches. For example, her right eye, the right side of her face, and her right arm are less clearly defined than the left. This demands some

8.3 To most observers, this image initially appears as a random pattern with no figure clearly visible. The perceptual experience elicited by this stimulus is radically, and perhaps permanently, altered after viewing the pattern shown in figure 8.4 (adapted from Albright 2012).

top-down processing on our part. Why is de Kooning disassembling her body? The only parts that appear intact and symmetrical are her breasts. This is an early attempt by de Kooning to redefine the female form.

Excavation (fig. 8.6), done ten years later, is a very different work that is largely abstract. It is essentially flat, with little sense of perspective. But knowing de Kooning and his fascination with the female form, our imagination need not wander far on this canvas to encounter rounded shapes that, depending on one's mood or disposition, easily recall one or more women alone or coupling with another person. There are almost unlimited possibilities in this painting for both bottom-up resolution of ambiguity and top-down imagination, as we can recall one possible association after another.

8.4 This image demonstrates the influence of associative pictorial recall (top-down signaling) on the interpretation of a retinal stimulus (bottom-up signaling). Most observers experience a clear, meaningful percept upon viewing this pattern. After seeing this image, the interpretation of the pattern in the previous figure (8.3) is perceived quite differently. Having once perceived figure 8.4, the observer can produce a figural interpretation driven largely by images drawn from memory (adapted from Albright 2012).

8.5 Willem de Kooning, *Seated Woman*, 1940

© The Willem de Kooning Foundation/Artists Rights Society (ARS), New York

The contrast between *Seated Woman* and *Excavation* is all the more remarkable because *Seated Woman* is already quite ambiguous.

Now let us turn to Pollock's early figurative painting *Going West* (fig. 8.7). We are struck by the ceaseless clockwise movement, beginning with the mules and their drivers, moving to the clouds and the moon in the sky, and coming around to the mules again.

8.6 Willem de Kooning, *Excavation*, 1950

© The Willem de Kooning Foundation / Artists Rights Society (ARS), New York

Fifteen years later, in *Number 32* (fig. 8.8), Pollock again creates a pow-
erful sense of movement. But now, rather than forcing a single, compelling
clockwise movement, Pollock frees us to choose any direction—or, more
likely, several directions—to track, as our eyes scan the canvas seeking order.
Are there any images here? Is any direction of movement particularly domi-
nant? The painting calls to my mind a battle of images, a scene of never-ending

8.7 Jackson Pollock, *Going West*, 1934–35

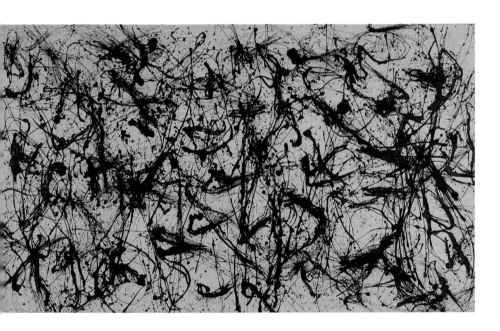

8.8 Jackson Pollock, *Number 32*, 1950

image warfare. It takes our breath away if we let our imagination wander to other scenes that might in any way be comparable.

What stands out in this comparison of de Kooning's and Pollock's paintings is that while abstract art is clearly reductionist in terms of figuration, it can encourage our imaginative capabilities to a far greater degree than many figurative counterparts would. Moreover, the two fully abstract paintings are less challenging to the bottom-up processing by our brain's visual machinery than Cubist art is. Cubist art often retains figurative elements, yet it asks us to explore them from different, unrelated perspectives that our brain did not evolve to process meaningfully. The abstract paintings, in contrast, seem to rely less on bottom-up processing, which primarily serves to resolve potential ambiguities; instead, they rely heavily on our imagination, our top-down associations from personal experiences and encounters with other works of art.

CHAPTER 9

FROM FIGURATION
TO COLOR ABSTRACTION

Mark Rothko and Morris Louis, to whom we now turn, took a different approach to abstraction. While Piet Mondrian reduced his paintings to lines and colors, Willem de Kooning introduced movement and tactile sensibility, and Jackson Pollock conveyed the raw creative process, Rothko and Louis reduced their paintings to color alone. In doing so they, like Mondrian, succeeded in imparting a new spiritual sense to the beholder. They also elicited a variety of raw emotional responses.

Rothko pioneered color-field painting in the 1950s and 1960s. He spread large areas of a more-or-less flat, single color across the canvas, creating visually gorgeous, lighter-than-air planes of unbroken color on its surface. It has been said that "none of the New York School was able to convey a more intense feeling of happiness. The color . . . suggested a wonderfully meditative peace" (Spies 2011, 8:89).

ROTHKO AND COLOR ABSTRACTION

Mark Rothko (fig. 9.1) was born Markus Rotkovich in Dinsk, a city in northwestern Russia, in 1903. Dinsk was part of the district called The Pale of Settlement, the only area in Russia in which Jews were allowed by law to

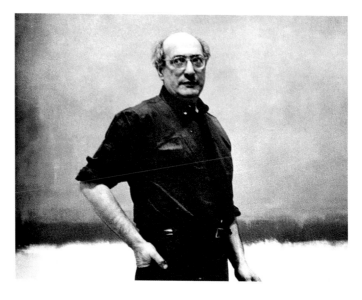

9.1 Mark Rothko (1903–1970)

reside. He moved to the United States with his family at age ten and settled in Portland, Oregon. He attended Yale University but left before graduating and moved to New York City in 1923, where he studied at the Art Students League and gradually emerged as a central figure in the New York School. Rothko developed a distinctive geometric abstraction by reducing images to color. Although his early figurative work in the 1930s was fairly unremarkable (fig. 9.2), it prefigured his more mature style in its blocklike treatment of figures and the layering of paint that gives those blocks a surprising luminosity and weightlessness. In places, the forms appear to be lit from within.

As Rothko developed his distinctive style, he became more reductionist, stripping from his paintings aspects of perspective and some references to recognizable imagery. He progressively eliminated precise, recognizable motifs from his paintings and focused on a few pictorial patterns. In *Couple Kissing 1934* (fig. 9.3), the colored shapes float and interact with one

9.2 Mark Rothko, *Untitled*, 1938

9.3 Mark Rothko, *Couple Kissing 1934*, 1934–35

another, clearly suggesting human figures. A decade later, in *No. 1 of 1948* (fig. 9.4), the suggestion of a human drama has been detached from the human form. Rothko speaks of stripping away these recognizable images as "an unveiling of a higher truth."

Rothko's work became most complex and challenging when it appeared simplest. By 1958 he had limited his use of forms even more and removed all semblance of human figuration, leaving a few colored rectangles stacked on a vertical field of color (fig. 9.5). This highly simplified, reductionist visual vocabulary focused on color and depth, and the astounding variety and beauty Rothko created with it defined his work for the rest of his life.

Rothko saw such reductionism as necessary: "The familiar identity of things has to be pulverized in order to destroy the finite associations with which our society increasingly enshrouds every aspect of our environment" (Ross 1991). Only by pushing the limits of color, abstraction, and reduction, he argued, can the artist create an image that liberates us from conventional

9.4 Mark Rothko, *No. 1 of 1948*, 1948–49

associations with color and form and allows our brain to form new ideas, associations, and relationships—and new emotional responses to them.

What at first sight appear to be monochromatic rectangles slowly take on form as we contemplate the painting, with planes of light delineated by slight shifts in hue or tonality (fig. 9.5). This and Rothko's other lushly colored abstract canvases are highly evocative. In spite of the paintings' radical simplicity, viewers consistently invoke mystical, psychic, religious references to describe their effects.

Rothko creates a startling sense of space and light on the canvas. Thin layers of paint applied in various degrees of saturation and transparency allow the background to show through intermittently, transforming the top layer into a luminous, translucent veil. There is no perspective in any conventional sense, only a suggestion of shallow space that brings the colors forward. In his work we see beautiful examples of how light emanates from motionless rectangles.

In the late 1960s Rothko took this minimalist approach even further. He shifted his focus from contrasting colors to the absence of color, the black canvas (Breslin 1993). The culmination of this work is a series of seven large canvases in coppery brown and black hues and seven plum-colored tonal paintings that occupy the walls of the Rothko Chapel in Houston, Texas (Barnes 1989). Rothko initially created twenty panels, only fourteen of which were eventually hung in the chapel (Cohen-Solal 2015).

The Rothko Chapel was commissioned in 1965 by John and Dominique de Menil as an interfaith sanctuary for human rights for the city where they lived, and adjacent to the de Menil Museum they had founded. The chapel was so named to draw a parallel with Our Lady Full of Grace of the Plateau d'Assy Chapel in France, which contains the work of Georges Braque, Henri Matisse, Fernand Léger, Marc Chagall, and many other modern artists, and to the Rosaire Chapel, which was designed by Matisse.

The chapel is a stark, windowless octagonal space with gray stucco walls. The building appears to have no other function than to display Rothko's works in a setting evocative of an early Christian church. The fourteen large panels form the interior of the chapel. Since the paintings are very dark, viewers often see nothing at all when they first enter the space. As they focus on the central canvas, however, they can begin to see some light emanating from it (fig. 9.6). They then sense movement, but it is uncertain whether the movement is on the canvas or in the viewer's body.

The large, baffled skylight, which the architects, Howard Barnstone and Eugene Aubry, added at Rothko's request, allows light to stream in at certain hours of the day. In the evening there is only the intense experience of the fading luminance of the paintings. Spies was struck by this contrast:

9.5 Mark Rothko, *#36 Black Stripe*, 1958

It is tempting to give primacy to this contrasting world of experiences: midday glare which, coming from the outside, darkens the dark picture even more, and evening light that for a while balances, lightens his darkness. The fact that Rothko did not want his pictures fixed by an unchanging light—by one optimal effect—is critical for Rothko's self-interpretation. . . . This relinquishing of one effect, of one exact illumination in

this ecumenical chapel might be seen as symbolic: as a renunciation of one truth, as the impossibility of favoring one light over another light. (Spies 2011, 8:85)

The sensation is both ambiguous and remarkable, and it affords us an opportunity to create new meaning. Moreover, the harmony among the beautifully displayed paintings in the chapel—a harmony that characterizes Rothko's late work—is striking. None of Rothko's figurative paintings are remotely capable of evoking as emotionally rich and varied, as spiritual, a response as these reductionist dark canvases. Dominique de Menil described the panels as "the result of his whole active life," and said that "he considered [the chapel] his masterpiece" (Cohen-Solal 2015, 190).

Color-field painting was a new direction within Abstract Expressionism, quite distinct from the action painting of de Kooning and Pollock. While Pollock's action paintings are perceived as vital and dynamic, Rothko's paintings consist of strong formal elements such as color, shape, balance, depth, composition, and scale. In focusing on color, Rothko was searching for a new style of abstraction that would link modern art to ancient mythic and transcendent art forms that reach out to the infinite. To achieve this, he abandoned figuration and focused exclusively on the expressive power of large fields of color. His experiments inspired a number of artists to follow his lead, to free color from objective contexts, inhibit access to figurative associations, and make it a subject on its own. In a way, Rothko succeeded in achieving what biologists, including biologists of perception and memory, try to do with reductionist science (see chapter 4).

Other color-field painters include Helen Frankenthaler, Kenneth Noland, Morris Louis, and Agnes Martin. All of these painters were greatly influenced by Rothko. As Martin put it, Rothko "reached zero so that nothing could stand in the way of truth." Like Rothko, the other color-field painters were interested in reductionism, in simplifying the complexities of art. But this new generation of painters placed more importance on form than on mythic content. As Rothko was to say about these later works, "A painting is not a picture of an experience. It is an experience."

9.6 Mark Rothko, *No. 7*, 1964

LOUIS'S APPROACH TO ABSTRACTION
AND REDUCTION OF COLOR

Morris Louis was born in 1912 in Washington, D.C., as Morris Louis Bernstein (fig. 9.7). He trained at the Maryland Institute of Fine and Applied Arts in Baltimore, from which he graduated in 1932. There, he became fascinated with how Matisse used color to create a light-filled atmosphere: rather than using shading to create volume, Matisse used contrasting areas of pure, modulated color. From 1936 to 1943 Louis lived in New York City, where he joined the easel division of the Federal Art Project. His early paintings from this era are figurative and rather routine scenes of poverty, workmen, and landscapes (figs. 9.8, 9.9).

9.7 Morris Louis (1912–1962) ca. 1950

9.8 Morris Louis, *Untitled (Two Women),* 1940–1941. 12 x 20 in. (30.5 x 50.8 cm)

9.9 Morris Louis, *Landscape,* ca. 1940s. 15 x 17 in. (38.1 x 43.18 cm),
Oil on canvas

While in New York, Louis came under the influence of Pollock and the New York School, but he soon turned from action painting to color-field painting, inspired by Rothko and, more directly, by Frankenthaler. In the context of a mutually supportive friendship and collaboration, Louis and Noland formed the nucleus of the Washington Color School, an extension of the New York School. The two began to develop a distinctive style of color-field painting, a continuation of Louis's interest in Matisse's use of color.

Louis thinned acrylic paint and poured it directly onto a large unstretched, unprimed canvas, which allowed the paint to follow its own course and soak directly into the material. As a result, the illusion of depth is eliminated and the color becomes an integral part of the surface (Upright 1985). This technique, in which paint moves freely without the interference of a brush or sticks, was a radical departure from action painting.

In April 1953 Noland brought Clement Greenberg to Washington to meet Louis. Greenberg was already one of America's most influential and thoughtful art critics and a major supporter of Pollock and Abstract Expressionism. Following the lead of Paul Cézanne and the Cubists, Greenberg saw that the distinctive feature of painting is its flatness; therefore, he thought that painting should purge itself of all illusions of depth and turn that concern over to sculpture.

Greenberg looked over Louis's work and was immensely impressed. He saw in it the essence of modernism. Louis used the characteristics of painting—flatness, the properties of the pigment—to criticize painting itself, and he did so in a way that radically deconstructed traditional easel paintings. Greenberg argued that whereas these characteristics of painting had traditionally been considered limitations and were acknowledged only indirectly, modernists regarded them as positive factors and acknowledged them openly. Louis's paintings were evidence of this perspective (see Greenberg 1955 and 1962).

In the four-year period between 1958 and his premature death in 1962, Louis produced three major series of paintings: the Veils, the Unfurled, and the Stripes. Each series consists of more than one hundred canvases that are

remarkably coherent and uniformly excellent. Louis developed his distinct types of paintings by manipulating the canvas and the process of painting. Exactly how he did this remains a mystery: he never wrote down his method, and he strictly forbade anyone from watching him work in his converted dining-room studio. All we know is that he used homemade stretchers to manipulate the canvas before pouring the paint over the surface.

The first of these series, the Veils, which Louis began in 1954, consists of up to twelve different colors lying on top of one another (figs. 9.10, 9.11). In these romantic paintings the artist gives the viewer the sense of a nineteenth-century landscape by using exaggerated versions of lines and colors that are commonly associated with—and thus symbolic of—earth, light, and sky. The paintings are gigantic, 7 feet by 12 feet. As Lipsey points out,

9.10 Morris Louis, *Green by Gold,* 1958

9.11 Morris Louis, *Saf,* 1959

the simple outlines of the colors against the neutral background of the canvas convey a sculptural presence. Louis referred to the forms as a "veil," an apparition rising freely from the canvas against the force of gravity. The colors are gentle, ranging from yellows to oranges and bronzes. Lipsey writes: "Like Rothko's classic images, Louis' images impose themselves as non-objective icons" (1988, 324).

In the summer of 1960 Louis began the Unfurled series. These paintings are his most readily identifiable, and perhaps most important, works. They are so named because Louis rolled the canvas before pouring the paint and then unrolled the canvas as the paint soaked into it. The paintings in this series are distinguished by a large open space in the top central area of the canvas. This area of the painting, which had conventionally been the most

important, even to Cubist artists, was now totally blank. Our attention is immediately drawn to the top of a painting because, as Wassily Kandinsky points out, it is the region that elevates the viewer's soul and mind. Another notable feature of these paintings is the two rainbow patterns that flow from the edges of the massive canvas toward the center (figs. 9.12, 9.13).

Unfurled represented a totally new idea in painting. At up to 20 feet wide, these are Louis's largest paintings—wider than the studio in which he created them. Though they seem like improvisations, they are in fact very systematic. In them Louis reversed the image of the veil by leaving open the wedge-shaped center and flowing paint into the white space surrounding it. Louis planned and executed the works carefully, destroying any that did not meet his standards.

Toward the end of his life, Louis painted the Stripes. These are bands of pure color with horizontal or, more commonly, vertical lines of the same intensity from top to bottom on extremely long, narrow canvases (figs. 9.14, 9.15). The bands appear capable of movement, and they interact with each

9.12 Morris Louis, *Alpha Tau*, 1960–1961

9.13 Morris Louis, *Delta, 1960*

other optically, depending on features such as their color and placement. Unlike the free-flowing paint in the previous series, the Stripes feature much more systematic, planned lines that look like naturally occurring rock formations. Greenberg describes the paintings as representing Louis's most puritanical work, an extreme form of reductionism that became purer and simpler in form as he went along.

In 1962 Louis was diagnosed with lung cancer, which was thought to have been abetted by prolonged inhalation of paint vapors. He died shortly afterward at his home at the age of forty-nine (Upright 1985; Pierce 2002).

9.14 Morris Louis, *Parting of Waters*, 1961

9.15 Morris Louis, *Third Element*, 1961. 85 1/2 x 51 in. (217.2 x 129.5 cm),
Acrylic resin (Magna) on canvas, DU458

THE EMOTIONAL POWER
OF COLOR-FIELD PAINTING

Both branches of Abstract Expressionism, action painting and color-field painting, exploit the separation between form and color, and both consciously give up form to emphasize line and color. By crafting softer outlines and vague contours, Pollock and de Kooning enable us to dedicate more of the brain's limited attentional resources to pattern. In emphasizing color per se, Rothko, Louis, and other color-field painters focus our attention even more sharply. Barnett Newman summarizes the effect of this achievement well:

> We are creating images whose reality is self-evident and which are devoid of the props and crutches that evoke associations with outmoded images, both sublime and beautiful. . . . The image we produce is the self-evident one of revelation, real and concrete, that can be understood by anyone who will look at it without the nostalgic glasses of history. (Newman 1948)

Although these images lack the recognizable forms of academic paintings, their explosive color range exerts enormous emotional power. Why is that so? One reason is that abstract paintings, with their lack of figuration, activate the brain very differently than figurative paintings do. Thus, color-field paintings exert their perceptual and emotional effects by eliciting associations in the beholder's brain that are related to color. As we shall see in the next chapter, this is important because the brain has specialized regions to process color.

CHAPTER 10

COLOR AND THE BRAIN

Modern abstract art was predicated on two major advances: the liberation of form and the liberation of color. The Cubists, led by Georges Braque and Pablo Picasso, liberated form. Since then, modern art has often represented the artist's subjective vision and state of mind rather than a naturalistic illusion of form based on the outside world. In the modern era it was largely Henri Matisse who liberated color, freeing it from form and thereby demonstrating that colors and color combinations can exert unexpectedly profound emotional effects.

Once color was no longer determined by form, a color that might have seemed "wrong" in a particular figurative context would actually be right, because it was used to convey the artist's inner vision, not to represent a particular object. Moreover, the separation of color from form is consistent with what we know about the anatomy and physiology of the primate visual system: that is, form, color, movement, and depth are analyzed separately in the cerebral cortex. Indeed, as Livingstone and Hubel (1988) point out, people who have had a stroke suffer surprisingly specific losses of color, form, movement, or depth.

COLOR VISION

Color vision, as we have seen, depends on cones, a class of light-sensitive cells that are concentrated in the center of the retina. Information processed by the cones, like that processed by the rods, is encoded in the cortex. Our eyes have three different types of cones. Each contains a different photo pigment, a molecule that converts information about light into neural signals, and each is sensitive to a particular range of wavelengths on the visible light spectrum (fig. 10.1). Our vision captures the relatively narrow band of wavelengths where the sunlight reaching Earth is most intense. It is also the band of wavelengths allowed in through the Earth's atmosphere, which absorbs shorter and longer wavelengths. So our visual system—and color vision—is another remarkable example of how we have evolved to make the best use of what is available to us in the environment.

Wavelengths in the visible light spectrum range from 380 nanometers, which we perceive as purple, to 780 nanometers, which we perceive as dark red. Because the three types of cones are sensitive to overlapping wavelengths of light, our visual system needs only three values—red, green, and blue—to represent the colors in the visible light spectrum: that is, the colors reflected by the simple structures typical of natural objects.

Color vision is essential for basic visual discrimination. It enables us to detect patterns that would otherwise go unnoticed and, together with variations in brightness, sharpens the contrast between the components of an image. But with color alone, without any variation in brightness, human vision is surprisingly poor at detecting spatial details.

Our brain processes different colors as having distinct emotional characteristics, but our reaction to the colors varies, depending upon the context in which we see them and our mood. Thus, unlike spoken language, which often has an emotional significance regardless of context, color is open to a great deal more top-down processing. As a result, the same color can mean different things to different people and to the same person in different contexts. In general, we prefer pure, bright colors to mixed, dull colors. Artists, particularly modernist painters, have used exaggerated colors as a way to

a.

electromagnetic spectrum

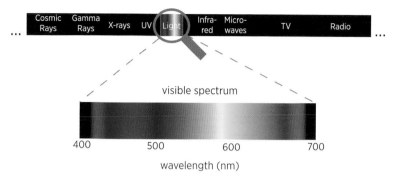

b.

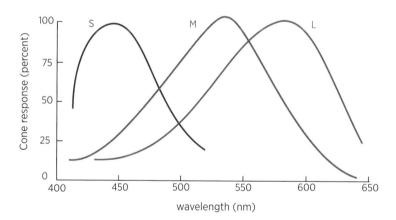

10.1 (a) The only light human eyes have evolved to see is called the visible spectrum (bottom spectrum), which takes up only a small fraction of the entire electromagnetic spectrum (top spectrum). (b) Overlapping sensitivity of the three types of cones.

generate emotional effects, but the value of that emotion depends on the viewer and the context. This ambiguity with respect to color may be another reason why a single painting can elicit such different responses from different viewers or from the same viewer at different times.

The development of emotive color by the Impressionists and Post-Impressionists was made possible by two technological breakthroughs in the mid-nineteenth century. The first was the introduction of a series of synthetic pigments that enabled artists to use a large range of vibrant, previously unavailable colors. The second was the availability of oil paints, already mixed, in tubes. Previously, artists had had to grind dry pigments by hand, then mix them carefully with a binding oil. With paints in tubes, artists could use a greater number of colors in their palettes, and they could paint outdoors, since the tubes were resealable and portable.

Given the impact that the color-field painters' works have on our emotions and imagination, it is not surprising that colors are as important to our brain as faces are. This is thought to be one of the reasons the brain processes color separately from light and from form. As we learned in chapter 3, the brain has six face patches in the inferior temporal cortex, each of which is specialized for processing specific information about faces. Recent studies have revealed that our brain has similar regions, located farther along the what pathway, that are thought to process information about color and about form (Lafer-Sousa and Conway 2013) (fig. 10.2).

Like face patches, the color-biased regions have an interactive, hierarchical arrangement, with each region processing progressively more selective information about color (Lafer-Sousa and Conway 2013, fig. 3.1). Although, as Livingstone and Hubel first showed, color is processed separately from form in the primary visual cortex, the color-biased regions in the inferior temporal cortex typically lie below the face patches and are connected to them (fig. 10.2). Color-biased regions and face patches generally do not overlap, however; they process information through networks that are interconnected but function largely independently of each other (Lafer-Sousa and Conway 2013; Tanaka et al. 1991; Kemp et al. 1996). Each network represents a complete functional representation of the object being viewed.

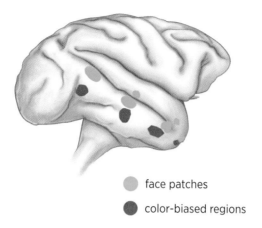

face patches

color-biased regions

10.2 Location of face patches and color-biased regions in the macaque brain.

COLOR AND EMOTION

The biological basis of the profound effect that color has on our emotional response to a work of art lies in the visual system's connections to other systems of the brain. The inferior temporal cortex, which houses the color-biased regions and face patches, has a direct connection to the hippocampus, which is concerned with memory, and to the amygdala, which orchestrates emotion.

The amygdala sends information to several regions of the visual cortex (Freese and Amaral 2005; Pessoa 2010), thereby influencing perception, including the perception of color. Daniel Salzman, Richard Axel, and their colleagues have found that certain cells in the amygdala respond selectively to pleasurable stimuli, whereas other cells respond selectively to frightening stimuli (Gore et al. 2015). Moreover, when a neutral stimulus is applied at the same time as a pleasurable stimulus to a cell that intrinsically responds to pleasurable stimuli, the neutral stimulus will become associated with the

pleasurable one and produce a pleasure response. In other words, the same cells that respond instinctively to pleasurable stimuli also become associated, through pairing, with learned pleasurable stimuli—and thus might influence perception by way of top-down processing. It is likely that some of these cells respond positively to certain colors or color combinations. If so, other images that we perceive or thoughts that those colors evoke will elicit a conditioned positive response. This phenomenon could be mediated by the same kind of mechanism of associative learning found in *Aplysia* (chapter 4).

The inferior temporal cortex connects to four additional regions of the brain: the nucleus accumbens, the medial temporal cortex, the orbitofrontal cortex, and the ventral lateral prefrontal cortex. These connections may contribute to the important role that faces and colors play in influencing behavior, their importance in our positive and negative emotional reactions, their ability to elicit pleasure, and our ability to recognize and categorize objects (Lafer-Sousa and Conway 2013).

While color is an important component of objects, it is not an isolated attribute. It is inextricably bound up with other attributes, such as brightness, form, and movement. As a result, color vision serves two distinct functions: together with brightness, color helps establish border ownership, and it disambiguates shadows and the elements in a group of objects. Thus, color enables us to find a given flower in a bouquet (fig. 10.3). Look, for example, at the purple and orange flowers in the top image. When color information is removed (middle image), the two different flowers are indistinguishable. In addition, color helps us identify surface attributes that we use to recognize objects (whether the flower is fresh or wilted).

In a larger sense, our brain needs to acquire knowledge about the permanent, essential properties of objects and surfaces in a world that is constantly changing (Meulders 2012). To do this, the brain must somehow discount all changes that are superfluous to an object. Our perception of color is an example of how the brain achieves this.

a. Full-color image

b. Black and white only

c. Color only

10.3 a. A normal full-color image of flowers contains information about variations in brightness and color. b. A black-and-white image captures variations in brightness, making it easy to discern spatial detail. c. A purely chromatic image contains no information about variations in brightness, only information about hue and saturation, making spatial detail hard to discern.

The light reflected off an object enters the eye and activates particular cones in the retina. Our brain unconsciously determines the wavelength composition of that light by taking into account both the surface reflectance of the object and the wavelength composition of the light illuminating the scene. Surface reflectance is the total quantity of visible light reflected by an object in all directions and at all wavelengths when illuminated by a light source—that is, the object's permanent, essential property. The brain infers the wavelength composition of the surrounding light from its effects on other features in the visual scene—that is, from the context. The brain then throws away, or discounts, information about illumination and extracts information about actual reflectance.

Reflectance is never constant, however; it changes continuously, depending upon the light illuminating the scene. Thus we view and recognize objects, such as a green leaf, under different conditions of illumination on a cloudy or a sunny day, sometimes at dawn, sometimes at midday, and sometimes at dusk. If we were to measure the wavelengths of the light reflected from that green leaf under these different conditions, we might find that the leaf at dawn is reflecting mostly red light, because mostly red light is around at that time of day. Yet we still see the leaf as green. Our brain's ability to maintain the essential color of the leaf is called *color constancy*. Indeed, if the green color of the leaf changed with every change in the wavelengths of light reflected from it, the leaf would no longer be recognizable by its color. Our brain would have to recognize it by some other attribute, and color would lose its significance as a biological signaling mechanism.

The environment surrounding an object also plays a critical role in determining its color. We see this in Rothko's *#36 Black Stripe* of 1958 (fig. 9.5), where the light reflected off the black stripe affects our perception of the reddish colors that surround it. Thus, even though color is dependent on the physical reality of wavelengths in the visible light spectrum, it, like other aspects of perception, is a property of the brain, not of the world outside.

A fascinating example of color ambiguity appeared on February 26, 2015. It all began when a woman shared with her daughter and future

son-in-law a photo of the dress she planned to wear to their wedding (Macknik and Martinez-Conde 2015). The daughter saw the dress as white with gold stripes, but the future son-in-law saw it as blue with black stripes. A friend of the bride posted the image of the dress on the Internet and asked the world at large what color it was (fig. 10.4). The ensuing debate dominated conversation in the social media and elsewhere for several days afterward. The two perceptions of the dress completely polarized viewers. People who saw the dress as white and gold refused to acknowledge the possibility that it was blue and black, and vice versa. How could people see the same dress so differently? The answer lies in the difference in lighting—and in the brain. It illustrates that lighting can override the usual, contextual definition of color.

Since color is mediated by cones, one explanation put forth for the difference in perception was that people have different ratios of red, green, and blue cones in their retinas. But as Cedar Riener of Randolph-Macon College has pointed out, even large differences in these ratios don't affect color sensitivity. We perceive color on the basis of luminance, the quantity of light that comes into our retina. Different people have different prior experiences (and thus different expectations) about the illumination in figure 10.4—not just its intensity but also its wavelength composition. Thus, just as we have different personal experiences and beliefs that we bring to bear on our perception of a work of art, or of a dress, so different personal histories and memories of them affect our color-processing mechanisms.

The appearance of an object also depends to a great extent on the contrast between the image and its surroundings. Thus, for example, even though the gray rings in figure 10.5 are of identical brightness, they appear to be different because their backgrounds produce different contrasts.

Our brain is always making decisions about the quantity of light coming into our retinas, discounting information about illumination and extracting information about surface reflectance. But in the case of the dress, visual perception is changing even though the context is not. Some people subtract out blue and see the dress as white and gold. Other people subtract out gold and see the dress as blue and black.

a.

b.

10.4 a. Is the dress white and gold? b. Is the dress blue and black?

10.5 The appearance of an object depends principally on the contrast between the object and its background. The two gray rings above are identical in brightness, but they appear to be different because their backgrounds produce different contrasts.

The illumination in figure 10.4 creates an unusual degree of ambiguity (Witzel 2015). It is hard to tell how the dress is lit. Is the light in the room bright or dim? Is the light yellow or blue? This ambiguity, combined with the fact that our brain unconsciously makes order out of noise in forming a particular perceptual decision, accounts for the different conclusions viewers reach regarding the color of the dress.

In reality, the stripes of the dress have known (and measurable) spectral content. The dress is in fact blue and black. But if we focus on the colors of background objects in the photos, we can see that there is too much light in figure 10.4a, which means that it is overexposed; therefore, the dress must be darker than it seems in that photo. People whose brains unconsciously reach this decision see the dress as blue. However, other people's brains make a different assumption regarding the lighting. Objects that are in shadow (and thus illuminated by reflected light from the blue sky, not by the sun itself) are in fact reflecting a fair bit of blue light. People whose brains unconsciously decide to ignore that reflected blue light see the dress as white.

Purves put all this in a perspective we now understand when he wrote: "People are wedded to the idea that colors are properties of objects, when they are in fact made up by the brain" (Hughes 2015). As the dress clearly illustrates, our perception of color is greatly influenced by top-down processes. The artist takes advantage of this fact, as well as the fact that colors often convey emotions, such as red representing love, courage, or blood and green representing spring or growth. But in every case it is the beholder who assigns meaning to the color, just as the beholder does to lines and textures.

A FOCUS ON LIGHT

n their search for a radically reduced form of art that would expand the beholder's imaginative involvement, some artists chose to create art solely with light and color, or simply with light. These works transform an exhibition space, physically incorporating the beholder within the art and often producing a hallucinatory effect.

FLAVIN AND FLUORESCENT LIGHT

Dan Flavin is an artist who has deliberately restricted his art to light and color (fig. 11.1). Flavin was born in Queens, New York, in 1933 and studied art history at Columbia University in the 1960s. During this period his drawings and paintings were influenced by the New York School. Later, he made collages that included objects he had found in the street, such as crushed cans. His first breakthrough occurred in 1963, with *The Diagonal of May 25, 1963 (to Constantin Brancusi)* (fig. 11.2). In this work Flavin used a store-bought fluorescent light, a medium that was to become his trademark. He positioned a single yellow fluorescent bulb, without any adornment or elaboration, against a gallery wall at a 45-degree angle. He called this tube his "diagonal of personal ecstasy."

11.1 Dan Flavin (1933–1996)

© Fred W. McDarrah / Premium Archive / Getty Images

Flavin's art consists of converting standard, commercially available fluorescent fixtures into glowing installation pieces that form environments of light and color. In early works, such as *icon V (Coran's Broadway Flesh)*, he attached light bulbs around the margin of his paintings (fig. 11.3). In time, the fluorescent light itself became the centerpiece of his work (figs. 11.2, 11.4). By making it evident that a fluorescent light bulb could stand on its own as a work of art, Flavin was following in the footsteps of Marcel Duchamp, a French artist whose early twentieth-century readymade works, such as his famous urinal and bicycle wheel, challenged the historical course of artistic creativity by illustrating that ordinary, utilitarian objects are works of art when placed in an artistic environment. This idea was further elaborated by Andy Warhol and Jeff Koons; they, like Flavin, showed that utilitarian objects could have spiritual values.

After *Diagonal*, Flavin went on to create *"Monument" for V. Tatlin* (fig. 11.4). In this work, one of a series of sculptures dedicated to the Russian

11.2 Dan Flavin, *The Diagonal of May 25, 1963 (to Constantin Brancusi)*, 1963

11.3 Dan Flavin, *icon V (Coran's Broadway Flesh)*, 1962

11.4 Dan Flavin, *"Monument" for V. Tatlin*, 1969

© Stephen Flavin/Artists Rights Society (ARS), New York

artist Vladimir Tatlin, Flavin combines fluorescent bulbs of different sizes into an architectural structure.

Flavin's pieces defy the conventional notion of art as object. Light emanates from the fixtures, pervading the atmosphere and reflecting off walls, floors, and viewer alike, blurring the distinction between ourselves and the art and letting us become part of it. Flavin's lush atmosphere of color and light establishes a unique relationship with the beholder: in the presence of one of his constructions, we see ourselves by its light and essentially discount other illumination in the room.

TURRELL AND THE PHYSICAL PRESENCE
OF LIGHT AND SPACE

James Turrell (fig. 11.5) extends the use of light in a completely different direction. Whereas Flavin creates environments of light and color, Turrell creates amazing artworks from the sheer physical presence of pure light and space. They are, as Danto (2001) has put it, "beautiful, impalpable oblongs of luminosity that one experiences as if [they were] mystical visions." The *New Yorker* art critic Calvin Tomkins elaborates on this idea, writing that Turrell's work is not about light or a record of light; "it *is* light—the physical presence of light made manifest in sensory form" (Tomkins 2003). His medium as an artist is pure light, and as a result, his work offers profound revelations about the perception and materiality of light.

With their refined formal language and quiet, almost reverential atmosphere, Turrell's installations allow viewers to explore light, color, and space. They bypass our conscious mind and access and celebrate the optical and emotional effects of luminosity on our unconscious.

11.5 James Turrell (1943–)

Turrell was born in Pasadena, California, and has been fascinated with light since childhood. He trained as a perceptual psychologist at Pomona College, where he studied the Ganzfeld effect. *Ganzfeld* is a German term for the entire visual field; it describes the experiences of a snowbound arctic explorer or a pilot navigating in dense fog. When everything in the visual field is the same color and brightness, our visual system shuts down. White is equivalent to black is equivalent to nothing. When this occurs for a long period of time, we are likely to experience hallucinations. Prisoners held in isolation cells also experience this phenomenon.

Turrell, who worked with NASA, emphasizes the idea, first introduced in the eighteenth century by Berkeley, that the reality we confront visually is a reality that we ourselves create: it is within the boundaries of our perceptual and cultural limitations. Turrell describes his work in the following

11.6 James Turrell, *Afrum I (White)*, 1967. Projected light. Dimensions variable.

terms: "My work has no object, no image and no focus. With no object, no image and no focus, what are you looking at? You are looking at you looking. What is important to me is to create an experience of wordless thought" (http://jamesturrell.com/about/introduction/).

Beginning in 1966 Turrell explored the various ways light can be manipulated to alter our perception of space. In *Afrum I (White)* (fig. 11.6), we perceive a solid object: a glowing cube floating in the corner of the room. Approaching the cube and examining it more closely, we realize that it is only a simple plane of light.

In contrast, in *Tight End* (fig. 11.7), a rectangular field of light casts a glow over the entire gallery space. As is the case with all of his work, the apparatus that Turrell uses to create these marvelous effects with light is not visible. This forces us to rely on our own perception to interpret what we see and what we experience.

11.7 James Turrell, *Tight End*, 2005

CHAPTER 12

A REDUCTIONIST INFLUENCE
ON FIGURATION

Although figuration never disappeared entirely, by the time Abstract Expressionism reached its peak, in the middle of the twentieth century, everyone in America seemed to agree that portraiture was finished as a progressive art form. Willem de Kooning expressed this idea clearly in 1960, saying, "It is absurd to make an image, like a human image, with paint." In 1968 *Time* magazine quoted the painter Alfred Leslie as saying that "modern art had, in a sense, killed figure painting." The artist Chuck Close remembers that in this period "the dumbest, most moribund, out-of-date and shopworn of possible things you could do was to make a portrait."

By the 1950s, however, a surprising trend had begun to develop. A number of artists, led by Alex Katz, Alice Neel, and Fairfield Porter, began to work specifically with figuration and portraiture, but with a new vision based on the lessons they had absorbed from abstraction—its gestural vitality, its vehemence, and its reductionism (Fortune et al. 2014). As we have seen, deconstruction of form in art began implicitly with J.M.W. Turner and Claude Monet and became explicit with the abstract painters of the New York School. The abstract painters influenced three new traditions, each of which continued to place a major emphasis on deconstruction.

The first tradition—a reductionist return to figuration—was pioneered by Katz, among others, who was familiar with the New York School and began to use monochromatic backgrounds for his simple, deconstructed portraits. Katz anticipated the second tradition—Pop Art—and he specifically influenced Roy Lichtenstein, Jasper Johns, and Andy Warhol. Warhol, in turn, influenced Close, who pioneered the third tradition—deconstruction followed by synthesis (for a detailed discussion of these artists, see Fortune et al. 2014).

Let us consider each of these in turn.

KATZ AND THE RETURN TO FIGURATION

Alex Katz (fig. 12.1) was born in Brooklyn, New York, in 1927 and studied at Cooper Union in New York and at the Skowhegan School of Painting and Sculpture in Skowhegan, Maine. He came of age during the reign of

12.1 Alex Katz (1927–)

Art © Alex Katz / Licensed by VAGA, New York, NY. Photo copyright 1996 Vivien Bittencourt

Jackson Pollock and de Kooning and was influenced by their Abstract Expressionism. In the small art world of New York, artists often interacted with each other, and Katz was no exception. He visited the Cedar Street Tavern, The Club, and other restaurants and bars where artists and writers went to exchange ideas. Although he was inspired by the scale and radical inventiveness of Abstract Expressionism and greatly influenced by Rothko's ability to convey color as having weight, Katz decided quite early in his career to focus on representational imagery. He was particularly fascinated by the possibility of merging reductive abstract techniques and ways of thinking with portraiture. In his bold use of color and stylized depiction of people, Katz anticipated Pop Art (Halperin 2012).

Katz introduced a new reductionist concept into figurative art: his paintings have a flat background and lack conventional perspective. In addition, he stressed pictorial values over narrative. He explained that "style and appearance are the things that I'm more concerned about than about what something means. I'd like to have style take the place of content, or the style be the content. . . . In fact, I prefer to be emptied of meaning, emptied of content" (Strand 1984).

His reductive tendencies in painting are further characterized by simplicity and heightened color, features later developed further by the Pop artists. Katz's portraits capture our eye and create a dialogue in our mind between figuration and abstraction. They take from Abstract Expressionism a monumental scale, stark composition, and dramatic lighting, which is flat, restrained, and minimalist. The portraits' characteristic flat, cropped faces linked them to commercial art and contributed to the comeback of figuration (figs. 12.2, 12.3). Katz's wife, Ada, is the subject of 250 paintings.

Of Katz's many important portraits, one that has attracted particular interest is that of Anna Wintour, the legendary standard-bearer of women's fashion and longtime editor of *Vogue*. Wintour is known for her love of color and her signature black sunglasses. Katz painted her without these in a soft light against a yellow background (fig. 12.4).

By duplicating his subject in the double portrait of Robert Rauschenberg (fig. 12.5), Katz removes the temptation to read an emotional meaning into

12.2 Alex Katz, *Sarah*, 2012

© Alex Katz/Licensed by VAGA, New York, NY

12.3 Alex Katz, *Joan (Walker 44)*, 1986

© Alex Katz/Licensed by VAGA, New York, NY.

12.4 Alex Katz, *Anna Wintour*, 2009

© Alex Katz/Licensed by VAGA, New York, NY

12.5 Alex Katz, *Double Portrait of Robert Rauschenberg*, 1959

© Alex Katz/Licensed by VAGA, New York, NY.

the interaction between two people. Serial repetitions of images were later used by Andy Warhol and others. Although Katz insists that his paintings of Rauschenberg and Wintour are empty of meaning and content, Spies points out that in these flat, puritanical portraits, with their self-assured coolness, there is a loneliness that recalls the work of Edvard Munch and a melancholy reminiscent of Edward Hopper (2011).

WARHOL AND POP ART

Pop Art first emerged as a movement in England in the mid 1950s and soon thereafter appeared in the United States in the work of Lichtenstein, Johns, and Warhol. It presented a challenge to traditional fine art by including imagery from popular culture. Whereas Pop Art, particularly that of Warhol, was strongly influenced by Katz and by Abstract Expressionism, it was neither abstract nor very reductionist. Rather, the flatness and pairing of images introduced by Katz stimulated Warhol to move in an entirely new direction.

Andy Warhol (fig. 12.6) was born in Pittsburgh, Pennsylvania, and graduated from the Carnegie Institute of Technology in 1949 with a Bachelor of Fine Arts degree in pictorial design. Shortly thereafter he moved to New York City and began working as an illustrator for fashion magazines. He later applied commercial design methods to portraiture, creating enduring and often enigmatic portraits of celebrities. After experimenting with hand painting, he turned to modified screen painting—a method based on photomechanical reproduction—which he used for the rest of his career.

Perhaps the most striking feature of Warhol's portraits is his use, following Katz, of multiple images of the same person—Jacqueline Kennedy, Marilyn Monroe, Elizabeth Taylor, Marlon Brando—thereby turning the person into an artistic icon. In these almost identical images of an individual he conveyed the elusiveness of a person's character and, by extension, of his or her identity. Thus no matter how familiar his subjects were to the public, Warhol portrayed them as essentially unknowable.

12.6 Andy Warhol (1928–1987)

© Fred McDorrah / Getty Images

12.7 Andy Warhol, *Marilyn Monroe Pink Fluorescent*, 1967

12.8 Andy Warhol, *Red Jackie*, 1964

12.9 Andy Warhol, *Jackie II*, 1964

Warhol's fascination with Jacqueline Kennedy began in the aftermath of President John F. Kennedy's assassination on November 22, 1963. By the time Warhol made his first image of her, in 1964, he had already produced silk screens of Elizabeth Taylor and Marilyn Monroe (fig. 12.7), as well as depictions of soup cans, flowers, and race riots. These themes—celebrity, tragic death, highly charged news events, consumerism, and contemporary decoration—were to remain central to his art, and several of them coalesced in his portraits of Jackie (figs. 12.8, 12.9).

Warhol often did multiple paintings and replicable prints with the idea—much like Katz—of erasing emotion through serialization. "The more you look at the same thing," he said, "the more the meaning goes away, and the better you feel" (Warhol and Hackett 1980). Warhol most commonly achieved emptiness by avoiding narrative and focusing on the banal. In the case of Jackie, however, he linked her tragic personal event to a tragic moment in our nation's history (Fortune et al. 2014).

CLOSE AND SYNTHESIS

Reductionism in brain science is often followed by attempts at synthesis, at reconstruction, to see whether the parts, when put together, explain the whole. Such synthesis is rare in art, but one artist—Chuck Close—stands out for this very reason.

Close (fig. 12.11) was born in Monroe, Washington, in 1940. He is severely dyslexic and did poorly in arithmetic and a number of other subjects in school. Fortunately, his parents were artists and encouraged his early creative interests.

When he was fourteen, Close saw Pollock's work at an exhibition, an experience that strengthened his resolve to become an artist. Close attended the University of Washington, where he developed an abstract style based on de Kooning's. On graduating, he enrolled in the Fine Arts Program at Yale. There, he radically changed his style from abstract painting to portraiture.

12.10 Chuck Close (1940–)

But this posed a problem, because Close also suffers from prosopagnosia, or face blindness. That is, he can identify a face as a face, but he cannot look at someone's face and recognize that person. In particular, Close had difficulty with the three-dimensionality of the face.

To reconcile the problem of face blindness with his desire to paint portraits, Close developed a new, reductionist-synthetic form of portraiture that combines photography and painting; this style later became known as photorealism. Close first takes a large-format Polaroid photograph of his

model. He then places a transparent sheet over the photograph and—in a step of radical reductionism—divides that transparent sheet into many small cubes, each of which he decorates in a distinctive way. Then—in a step of synthesis—he transfers the decorated cubes onto the canvas. Thus, Close achieves a paradoxical result in having a reductive process lead to a complex and richly detailed end result.

By 1960 Close and his photorealism had achieved widespread recognition in the New York art scene and, together with Katz and his work, helped to resurrect portrait painting as a challenging new form of contemporary

12.11 Chuck Close, *Maggie*, 1996

expression. By 1970 Close was considered one of America's outstanding living artists. His mezzotints and the grid lines on which they are based now characterize many of his portraits.

Throughout his career Close has painted a single subject: the human face. His faces include self-portraits and portraits of his children, his friends, and fellow artists. Each face is built on that carefully constructed grid of colorful squares, so when you stand close to the portrait of Maggie or Shirley, for example, you see only the radical reduction of the portrait into a grid, but as you step progressively farther back, you see the synthesis of those grids into a face (figs. 12.11, 12.12). The portraits also illustrate Close's philosophy that one's identity is a highly constructed composite.

12.12 Chuck Close, *Shirley*, 2007

PART 4

THE EMERGING DIALOGUE BETWEEN ABSTRACT ART AND SCIENCE

WHY IS REDUCTIONISM
SUCCESSFUL IN ART?

The abstract artists of the New York School succeeded in reducing the complex visual world around us to its essence of form, line, color, and light. This approach contrasts sharply with the history of Western art from Giotto and the Florentine Renaissance to Monet and the French Impressionists. Post-Renaissance artists attempted to create an illusion of the three-dimensional world on a two-dimensional canvas, but with the advent of photography in the middle of the nineteenth century, artists felt the need to create a new form—an abstract, nonfigurative art—that would incorporate some of the new ideas emerging from science. Artists also began to see analogies between their abstract work and music, which has no content, uses abstract elements of sound and division of time, and yet moves us enormously.

We are at a very early stage of exploring the biological underpinnings of our response to art, but we do have some clues as to why abstract art can elicit an active, creative, and enriching response in the beholder. These clues are only a beginning, however. We also want to understand why reductionism can succeed in distilling the most essential and powerful aspects of art and why it sometimes evokes a sense of spirituality.

One reason may be that some abstract works, with their reduction of figuration, color, and light, are uncluttered. Yet even when an abstract work

is cluttered, like an action painting by Jackson Pollock, it generally does not rely on an external framework of knowledge. Each work is highly ambiguous, as great poetry is, and each focuses our attention on the work itself, without reference to people or objects in the external environment. As a result, we project our own impressions, memories, aspirations, and feelings onto the canvas. It is like a perfect psychoanalytical transference, where the patient imposes upon the therapist a replay of experiences with parents and other important individuals, or like the repetition of a word or a tone in Buddhist meditation.

As is clear from the work of Piet Mondrian and the color-field painters, top-down information contributes greatly to the uplifting sense of spirituality that abstract art can induce. That is because top-down processing involves brain systems that are concerned with memory, emotion, and empathy as well as visual perception.

The suggestion that abstract art allows us to project our own imagination onto the canvas without the constraint of what Rothko called "the familiar identity of things" raises a larger question: How does our response to abstract art differ from our response to figurative art? What does abstract art offer to the beholder?

ABSTRACT ART'S NEW RULES FOR VISUAL PROCESSING

Bottom-up and top-down processing have not contributed to the beholder's share in equal measure throughout the history of Western art. We can see this by comparing a Renaissance painting with an abstract painting.

The Renaissance painting conforms to our brain's rules regarding the normal extraction of information about depth from the pattern of light on the retina. It uses the elements of perspective, foreshortening, modeling, and chiaroscuro to re-create the three-dimensional natural world—the same tools that evolved to enable our brain to infer the three-dimensional source of the flat, two-dimensional images on our retinas (a skill that is critical to our survival). In fact, one can well argue that classical painters'

experiments in perspective, illumination, and form—from Giotto and other early Western figurative painters to the Impressionists, the Fauves, and the Expressionists—recapitulate intuitively the computational processes that give rise to bottom-up processing. Even though da Vinci, Michelangelo, and other mannerist artists of the sixteenth century rebelled against this trend, the general thrust of Western art before the early twentieth century was to re-create the image that a three-dimensional world casts on a flat surface.

In abstract painting, elements are included not as visual reproductions of objects, but as references or clues to how we conceptualize objects. In describing the world they see, abstract artists not only dismantle many of the building blocks of bottom-up visual processing by eliminating perspective and holistic depiction, they also nullify some of the premises on which bottom-up processing is based. We scan an abstract painting for links between line segments, for recognizable contours and objects, but in the most fragmented works, such as those by Mark Rothko, Dan Flavin, and James Turrell, our efforts are thwarted.

Thus the reason abstract art poses such an enormous challenge to the beholder is that it teaches us to look at art—and, in a sense, at the world—in a new way. Abstract art dares our visual system to interpret an image that is fundamentally different from the kind of images our brain has evolved to reconstruct.

As Albright has pointed out (personal communication), we "search" desperately for associations because our survival is dependent upon recognition. In the absence of strong figurative clues, we create new associations. The philosopher David Hume makes a similar point: "The creative power of the mind amounts to no more than the faculty of compounding, transposing, augmenting, or diminishing the materials afforded us by the senses and experience" (Hume 1910).

The art historian Jack Flam (2014) refers to this aspect of abstraction as "a new claim on truth." By dismantling perspective, abstract art requires our brain to come up with a new logic of bottom-up processing. The work of Mondrian relies heavily on the brain's early steps in processing objects, steps that depend on line segments and axis of orientation, and on the brain's

processing of color. But these bottom-up processes are likely to be modified or overridden altogether by extensive, creative top-down processing.

Figurative paintings—landscapes, portraits, and still lifes—evoke activity in the regions of the brain that respond to category-specific images. Imaging studies of brain function have now shown that abstract art does not activate category-specific regions; rather, it activates the regions that respond to all forms of art (Kawabata and Zeki 2004). Thus, we view abstract art by exclusion; we seem to realize unconsciously that what we are looking at does not belong to any specific category (Aviv 2014). In a sense, one of the perceptual achievements of abstract art is to expose us to less familiar or even totally unfamiliar situations.

In a broader sense, the beholder's response can be thought of as consisting of three main perceptual processes: the brain's analysis of the pictorial content and style of the image; the top-down cognitive associations recruited by the image; and our top-down emotional responses to the image (see Bhattacharya and Petsche 2002). The very abstraction of an image gives us a certain detachment from reality, and this encourages top-down free associations, which we find rewarding. Eye-tracking experiments reveal that when we view abstract art, our brain tends to scan the whole surface of the painting rather than focusing on recognizable, salient features (Taylor et al. 2011).

Actually, we look all the time at simple surfaces that are remarkably like minimalist paintings: walls, chalkboards, and so on. Modern minimalist artists realized that by creatively framing these simple surfaces and playing with tactile values, color, and light, they could evoke imaginative responses from the beholder.

We see this idea in the work of Fred Sandback (fig. 13.1), who stretched store-bought acrylic yarn between different points on a wall to outline simple geometric shapes, such as squares or triangles. Like other minimalist artists, Sandback wanted to focus the viewers' attention on the moment, on the here and now. By not providing any solid objects or symbolic references, his images, seen in this novel context, allow us to experience how our visual perception can alter the basic facts displayed on the wall (fig. 13.2).

13.1 Fred Sandback (1943–2003), Galerie Annemarie Verna, Zurich, 2000

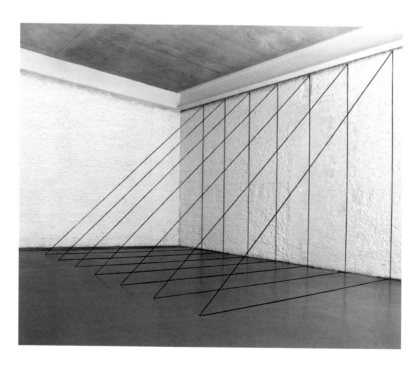

13.2 Fred Sandback, *Untitled* (Sculptural Study, Seven-part Right-angled Triangular Construction), ca. 1982/2010. Black acrylic yarn. Situational: spatial relationships established by the artist; overall dimensions vary with each installation.

Sandback says of his initial exploration, "The first sculpture I made with a piece of string and a little wire was the outline of a rectangular solid . . . lying on the floor." It was a casual act, but it opened up a host of opportunities for him to create sculpture that did not have an interior. It allowed him to assert a certain place or volume in its full materiality without taking up any space. The untitled sculpture in figure 13.2 looks three-dimensional because it is in a corner, but putting that flat rectangle on the floor has the same effect. It makes the viewer feel as though it has sides that extend upward. The amazing thing about these works of art is that we concentrate less on the edges that outline the space—the yarn—than on the volume contained within it.

In exploring the interplay of vacancy and volume, the immaterial and the concrete, Sandback realized that the illusory and the factual are inextricably intertwined. He asserts in a radical reductionist manner that "fact and illusions are equivalents."

THE BEHOLDER AS CREATIVE VIEWER

Abstract artists such as Mondrian, Rothko, and Morris Louis understood intuitively that visual perception is an elaborate mental process, and they experimented extensively with ways to engage various aspects of the viewer's attention and perception. Mondrian and Rothko distilled both form and color, and in doing so they called attention to art in psychologically new ways. As Pollock pointed out, abstraction allows artists to demonstrate that art can exist on the canvas or a sheet of paper, a two-dimensional surface, in the same way it exists in the unconscious mind—independent of nature, time, and space.

This new view altered forever how artists depict the world before them. It also altered how we apprehend images—by free association in response to clues such as patches of color, light, and lines of various orientations. Consequently, abstract art, and Cubism before it, posed what is probably the most radical challenge to the viewer's perception in the history of art. It requires

the beholder to substitute primary process thinking—the language of the unconscious, which easily forms connections between different objects and ideas and has no need of time or space—for secondary process thinking—the language of the conscious ego, which is logical and requires time and space coordinates. Abstraction deformed our normal habits of perception as they apply to the viewing of art, as well as our expectations of what we might see in art.

As a result, the visual arts no longer parallel the operations of the brain's bottom-up processing of visual information. Abstract art, like Cubism, put an end to what the art critic Carl Einstein called "the laziness or fatigue of vision. Seeing had again become an active process" (Einstein 1926; cited in Haxthausen 2011).

Ernst Kris and Abraham Kaplan (1952), who appreciated that the beholder is not a passive participant in art but a creative force in his or her own right, first advanced the idea that unconscious mental processes are important contributors to creativity. Creativity removes the barrier between our conscious and unconscious selves and enables them to communicate in a relatively free, yet controlled manner. He called this controlled access to unconscious thought "regression in the service of the ego." Since the beholder undergoes a creative experience in viewing a work of art, the beholder as well as the artist experiences this controlled communication with the unconscious.

CREATIVITY AND THE DEFAULT NETWORK: ABSTRACT ART

While abstract paintings that appeal to our imagination call into play the brain's top-down processing mechanism, figurative paintings that appeal to us call into play the default network of the brain. The default network, which was discovered in 2001 by Marcus Raichle (Raichle et al. 2001), consists primarily of three brain regions: the medial temporal lobe, which is involved in memory; the posterior cingulate cortex, which is concerned with

evaluating sensory information; and the medial prefrontal cortex, which is concerned with theory of mind—that is, with distinguishing between another person's mind, his or her aspirations and goals, and one's own mind.

The default network is active when we are resting but suppressed when we are dealing with the world. It comes into play, for example, while we are daydreaming or recalling memories or listening to music. Because it is concerned with introspection independent of any particular task, the default network seems to comprise what ego psychologists like Kris call *preconscious mental processes.* These processes intervene between conscious and unconscious thought; they have access to consciousness but are not immediately present in consciousness. More recently, the default network has been related to stimulus-independent thought and mental activities that are thought to rely heavily on preconscious thought.

Recent studies suggest that the default network is most active during high aesthetic experiences in art. Edward Vessel, Nava Rubin, and Gabriella Starr made this discovery by combining behavioral analysis of individual differences in the evaluation of a set of paintings with images of brain functioning. They asked volunteers to look at four paintings while in the imaging scanner, where the activity of different regions of the brain can be detected, and to rank the paintings on a scale of 1 (least appealing) to 4 (most appealing). Vessel and his colleagues found that the default network was recruited into activity only by the most intense response, a rating of 4 — never by ratings of 1, 2, or 3.

This intriguing finding suggests that since activation of the default network is related to our sense of self, its activation in response to art enables our perception of painting to interact with mental processes related to the self, possibly affecting them and even being incorporated into them (Vessel et al. 2012; Starr 2014). This line of thought is consistent with the idea that a person's taste in art is linked to his or her sense of identity.

ABSTRACT ART AND THE CONSTRUAL-LEVEL THEORY
OF PSYCHOLOGICAL DISTANCE

The cognitive logic recruited for the top-down processing of abstract art may not be unique to the perception of art, but could represent a more general logic used in other contexts as well. A general form of this logic is evident in construal-level theory, a psychological concept that measures abstract as opposed to concrete thought processes and distinguishes between them based on different psychological distances and how they affect us (Trope and Liberman 2010). Construal-level theory suggests that thinking styles are plastic and can be modified by circumstances, specifically by varying psychological distance. Empirical studies show that things psychologically near to us, such as images of people and objects that we experience as here and now, are seen by us as concrete, whereas things that are not here and now seem more distant. The distant things actually increase our creativity, which is indeed what occurs with top-down processing.

Thus, beauty is not only in the eye of the beholder, it is also in the preconscious creative processes of the beholder's brain. It will therefore be interesting to see whether the profound sense of spirituality that abstract art imparts to some beholders results in part from its activation of their default network, an activation that according to construal theory requires a considerable distance from the here and now.

The New York art critic Nancy Princenthal described abstract art in the following terms:

> To be abstracted is to be at some distance from the material world. It is a form of local exaltation but also, sometimes, of disorientation, even disturbance. Art at its most powerful can induce such a state, art without literal content perhaps most potently. (Princenthal 2015)

A RETURN TO
THE TWO CULTURES

The evolutionary biologist E. O. Wilson envisions bridging the gap between C. P. Snow's two cultures—the sciences and the humanities—with a series of dialogues similar to the ones that took place earlier between physics and chemistry, and between those two fields and biology (Wilson 1977).

In the 1930s Linus Pauling demonstrated that the physical principles of quantum mechanics explain how atoms behave in chemical reactions. Stimulated in part by Pauling's work, chemistry and biology began to converge in 1953 with the discovery of the molecular structure of DNA by James Watson and Francis Crick. Armed with this structure, molecular biology unified in a brilliant way the previously separate disciplines of biochemistry, genetics, immunology, development, cell biology, cancer biology, and, more recently, molecular neurobiology. This unification set a precedent for other scientific disciplines, and it may set a precedent for brain science and art as well.

Wilson argues that knowledge is gained and science progresses through a process of conflict and resolution. For every parent discipline, there is a more fundamental field, an antidiscipline that challenges its methods and claims (Wilson 1977; Kandel 1979). Typically, the parent discipline is larger in scope and deeper in content, and it ends up incorporating and benefiting from the antidiscipline. These are evolving relationships, as we can see with

art and brain science. Art and art history are the parent disciplines, and brain science is their antidiscipline.

Dialogues are most likely to be successful when fields of study are naturally allied, as the new science of mind and the perception of art are, and when the goals of the dialogue are limited and benefit all of the fields that contribute to it. Such dialogues might take place today in the modern equivalent of the famous salons of Europe—that is, in the interdisciplinary centers at universities. The Max Planck Society in Germany has a new Institute on Art and Science, as do several American universities. It is unlikely that a unification of the new science of mind and aesthetics will occur in the foreseeable future, but a new dialogue is emerging between people interested in aspects of art, including abstract art, and people interested in aspects of the science of perception and emotion. In time, the conversation may have a cumulative effect.

The potential benefits of this dialogue for the new science of mind are obvious. One of the aspirations of this new science is to link the biology of the brain to the humanities. One of its goals is to understand how the brain responds to works of art, how we process unconscious and conscious perception, emotion, and empathy. But what is the potential usefulness of this dialogue for artists?

Since the beginning of modern experimental science in the fifteenth and sixteenth centuries, artists have been interested in science, as exemplified by Filippo Brunelleschi and Masaccio, Leonardo da Vinci, Albrecht Dürer and Pieter Brueghel, the abstract painting of Schoenberg, and the works of Richard Serra and Damien Hirst. Much as da Vinci used his knowledge of human anatomy to depict the human form in a more compelling and accurate manner, contemporary artists may use our new understanding of the biology of perception and of emotional and empathic response to create new art forms and other expressions of creativity.

Indeed, some artists who are intrigued by the irrational workings of the mind, including Jackson Pollock and Willem de Kooning as well as René Magritte and other Surrealists, have attempted this already, relying on introspection to infer what was happening in their own minds. Although

introspection is helpful and necessary, it is not capable of providing a detailed understanding of the brain, its workings, and our perception of the outside world. Artists today can enhance traditional introspection with the knowledge of how some aspects of our mind work.

Since 1959, when Snow first talked about the two cultures, we have found that science and art (including abstract art) can interact and enrich each other. Each brings its particular perspectives to bear on essential questions about the human condition, and each uses reductionism as a means of doing so. Moreover, the new science of mind seems on the verge of bringing about a dialogue between brain science and art that could open up new dimensions in intellectual and cultural history.

ACKNOWLEDGMENTS

For his inauguration as President of Columbia University, Lee Bollinger organized a series of symposia, one of which concerned "Perception, Memory, and Art" (Oct. 3, 2002). It was on this occasion that I first presented a preliminary version of the ideas developed in this book under the title "Steps Towards a Molecular Biology of Memory: A Parallel Between Radical Reductionism in Science and Art." A modified version of this talk subsequently appeared in the *Annals of the New York Academy of Sciences* as "A Parallel Between Radical Reductionism in Science and Art" (2003).

The beholder's share is discussed in the context of figurative art in Eric Kandel, *The Age of Insight: The Quest to Understand the Unconscious in Art, Mind, and Brain from Vienna 1900 to the Present* (New York: Random House, 2012), particularly chapters 11–18 and the references therein. The beholder's response to Cubist art is discussed in Eric Kandel, "The Cubist Challenge to the Beholder's Share," in *Cubism: The Leonard A. Lauder Collection* (Metropolitan Museum of Art, 2014). I also relied on material discussed in *Principles of Neural Science*, 5th ed., edited by Eric R. Kandel, James H. Schwartz, Thomas M. Jessell, Steven A. Siegelbaum, and A. J. Hudspeth (New York: McGraw Hill, 2012). Finally, I have drawn further on a number of historical and contemporary sources listed in the references.

I have benefited greatly from the comments and criticisms of a number of colleagues and friends. In particular, I am indebted to Tom Jessell, my colleague at Columbia; to Emily Braun and Pepe Karmel, two gifted art historians; and to Thomas Albright, a visual neuroscientist, for their thoughtful and detailed criticisms of two earlier drafts of this book. I have also had the benefit of helpful comments from Tony Movshon, Bobbi and Barry Coller, Mark Churchland, Denise Kandel, Michael Shadlen, and Lou Rose. I thank my colleagues Daphna Shohamy and Celia Durkin for calling the construal-level theory to my attention. I am once again deeply indebted to my wonderful editor Blair Burns Potter, who worked with me on my two earlier books and brought her critical eye and her insightful editing to this volume. I am also indebted to my long-term colleague and collaborator Sarah Mack for her help with the art program and with parts of the text. Finally, I am much indebted to Pauline Henick, who typed the many early versions of this manuscript with patience and care, and obtained permission for all the works of art.

NOTES

INTRODUCTION

1. In his essay C. P. Snow focused specifically on humanist scholars who were literary intellectuals. But the essay applies to all the humanists and has generally been interpreted more broadly (see for examples Wilson 1977, Ramachandran 2011).

2. The term *Abstract Expressionism* actually has a long history. It was first used in 1919 by the German magazine *Der Sturm* to describe German Expressionism. In 1929 Alfred Barr, the first director of the Museum of Modern Art, applied the term to the work of Wassily Kandinsky. It was first applied to the New York School in 1946 by the art critic Robert Coates.

 C. P. Snow followed up his original Rede Lecture of 1959 on *The Two Cultures and the Scientific Revolution* with *The Two Cultures: A Second Look,* published in 1963. In this second book Snow introduced the idea, which I emphasize here, that there can be mediating third cultures. The notion of third cultures was elaborated upon by John Brockman in *The Third Culture: Beyond the Scientific Revolution* (1995).

 In my book on figurative art and science, *The Age of Insight* (2013), I discuss the two cultures in the following terms:

 In the decades since Snow's lecture, the gulf separating the two cultures has begun to narrow. Several things have contributed to that narrowing. The first was Snow's coda to the second edition of his book *The Two Cultures: A Second Look*, published in 1963. In it, he discusses the extensive response to his lecture and describes the possibility of a third culture that could mediate a dialogue between scientists and humanists:

With good fortune, however, we can educate a large proportion of our better minds so that they are not ignorant of imaginative experience, both in the arts and in science, nor ignorant either of the endowments of applied science, of the remediable suffering of most of their fellow humans, and of the responsibilities which, once they are seen, cannot be denied.

Thirty years later, John Brockman advanced Snow's idea in his essay "The Third Culture: Beyond the Scientific Revolution." Brockman emphasized that the most effective way of bridging the divide would be to encourage scientists to write for the general public in a language that an educated reader can readily understand. This effort is currently under way in print, on radio and television, on the Internet, and in other media: good science is being successfully communicated to a general audience by the very scientists who created it (Kandel 2013, 502). For a discussion of reductionism in biology, see:

Crick, Francis. 1966. *Of Molecules and Men*. Seattle: University of Washington Press.

Squire, L. and E. R. Kandel. 2008. *Memory: From Mind to Molecules*. 2nd ed. Englewood, Colo.: Roberts and Co.

1. THE EMERGENCE OF A REDUCTIONIST SCHOOL OF ABSTRACT ART IN NEW YORK

For a discussion of the New York School and the movement of the center of art from Paris to New York, see:

Greenberg, C. 1955. "American Type Painting." *Partisan Review* 22: 179–196. Reprinted in *Art and Culture* (Boston: Beacon, 1961, 208–229).

Rosenberg, Harold. 1952. "The American Action Painters." *Art News* (December).

Schapiro, M. 1994. *Theory and Philosophy of Art: Style, Artist, and Society*. New York: George Braziller.

2. THE BEGINNING OF A SCIENTIFIC APPROACH TO ART

Kandel, E. R. 2012. *The Age of Insight: The Quest to Understand the Unconscious in Art, Mind, and Brain from Vienna 1900 to the Present*. New York: Random House.

Riegl, A. 2000. *The Group Portraiture of Holland*. Trans. E. M. Kain and D. Britt. 1902; reprint, Los Angeles: Getty Research Institute for the History of Art and the Humanities.

3. THE BIOLOGY OF THE BEHOLDER'S SHARE:
VISUAL PERCEPTION AND BOTTOM-UP PROCESSING IN ART

Albright, T. 2015. "Perceiving." *Daedalus* (winter 2015): 22–41.

Freiwald, W. A., and D. Y. Tsao. 2010. "Functional Compartmentalization and Viewpoint Generalization Within the Macaque Face-Processing System." *Science* 330:845–851.

Gilbert, C. 2013. "Top-Down Influences on Visual Processing." *Nature Reviews Neuroscience* 14: 350–363.

Zeki, S. 1999. *Inner Vision: An Exploration of Art and the Brain.* Oxford: Oxford University Press.

4. THE BIOLOGY OF LEARNING AND MEMORY:
TOP-DOWN PROCESSING IN ART

Kandel, E. R. 2006. *In Search of Memory: The Emergence of a New Science of Mind.* New York: Norton.

Kandel, E. R., Y. Dudai, and M. R. Mayford, eds. 2016. *Learning and Memory.* Cold Spring Harbor, N.Y.: Cold Spring Harbor Laboratory Press.

5. REDUCTIONISM IN THE EMERGENCE OF ABSTRACT ART

Gooding, M. 2000. *Abstract Art.* London: Tate Gallery.

6. MONDRIAN AND THE RADICAL REDUCTION
OF THE FIGURATIVE IMAGE

Lipsey, R. 1988. *An Art of Our Own: The Spiritual in Twentieth-Century Art.* Boston and Shaftesbury: Shambhala.

Spies, W. 2010. *Path to the Twentieth Century: Collected Writings on Art and Literature.* New York: Abrams.

Zeki, S. 1999. *Inner Vision: An Exploration of Art and the Brain.* Oxford: Oxford University Press, chapter 12.

7. THE NEW YORK SCHOOL OF PAINTERS

Naifeh, S. and G. Smith. 1989. *Jackson Pollock: An American Saga.* New York: Potter.

Stevens, M. and A. Swan. 2005. *De Kooning: An American Master.* New York: Random House.

8. HOW THE BRAIN PROCESSES AND PERCEIVES ABSTRACT IMAGES
Albright, T. 2015. "Perceiving." *Daedalus* (winter 2015): 22–41.

9. FROM FIGURATION TO COLOR ABSTRACTION
Breslin, J.E.B. 1993. *Mark Rothko: A Biography*. Chicago: University of Chicago Press.
Princenthal, N. 2015. *Agnes Martin: Her Life and Art*. New York: Thames & Hudson.

10. COLOR AND THE BRAIN
Zeki, S. 2008. *Splendors and Miseries of the Brain: Love, Creativity, and the Quest for Human Happiness*. Hoboken, N.J.: Wiley-Blackwell.

11. A FOCUS ON LIGHT
Miller, D., ed. 2015. *Whitney Museum of American Art: Handbook of the Collection*. New York: Whitney Museum.
Spies, W. 2011. *The Eye and the World: Collected writings on Art and Literature*. Vol. 8: Between Action Painting and Pop Art. New York: Abrams.

12. A REDUCTIONIST INFLUENCE ON FIGURATION
Fortune, B. B., W. W. Reaves, and D. C. Ward. 2014. *Face Value: Portraiture in the Age of Abstraction*. Washington, D.C.: GILES in association with the National Portrait Gallery, Smithsonian Institution.

13. WHY IS REDUCTIONISM SUCCESSFUL IN ART?
Gombrich, E. H. 1982. *The Image and the Eye: Further Studies in the Psychology of Pictorial Representation*. London: Phaidon.

14. A RETURN TO THE TWO CULTURES
Kandel, E. R. 1979. "Psychotherapy and the Single Synapse: The Impact of Psychiatric Thought on Neurobiologic Research." *New England Journal of Medicine* 301:1028–1037.
Wilson, E. O. 1977. "Biology and the Social Sciences." *Daedalus* 2:127–140.

REFERENCES

Adelson, E. H. 1993. "Perceptual Organization and the Judgment of Brightness." *Science* 262:2042–2043.

Albright, T. 2012. "TNS: Perception and the Beholder's Share." Discussion with Roger Bingham. The Science Network. http://thesciencenetwork. org/.

——. 2012. "On the Perception of Probable Things: Neural Substrate of Associative Memory, Imagery, and Perception." *Neuron* 74:227–245.

——. 2013. "High-Level Visual Processing: Cognitive Influences." In *Principles of Neural Science,* 621–653. New York: McGraw-Hill.

——. 2015. "Perceiving." *Daedalus* 144 (1) (winter 2015): 22–41.

Antliff, M., and P. Leighten. 2001. "Philosophies of Space and Time." In *Cubism and Culture*, 64–110. New York: Thames & Hudson.

Ashton, D. 1983. *About Rothko.* New York: Oxford University Press

Aviv, V. 2014. "What Does the Brain Tell Us About Abstract Art?" *Frontiers in Human Neuroscience* 8:85.

Bailey, C. H., and M. C. Chen. 1983. "Morphological Basis of Long-Term Habituation and Sensitization in *Aplysia.*" *Science* 220:91–93.

Barnes, S. 1989. *The Rothko Chapel: An Act of Faith.* Houston: Menil Foundation.

Bartsch, D., M. Ghirardi, P. A. Skehel, K. A. Karl, S. P. Herder, M. Chen, C. H. Bailey, and E. R. Kandel. 1995. "*Aplysia* CREB2 Represses Long-Term Facilitation: Relief of Repression Converts Transient Facilitation Into Long-Term Functional and Structural Change." *Cell* 83:979–992.

Bartsch, D., A. Casadio, K. A. Karl, P. Serodio, and E. R. Kandel. 1998. "CREB1 Encodes a Nuclear Activator, a Repressor, and a Cytoplasmic Modulator That Form a Regulatory Unit Critical for Long-Term Facilitation." *Cell* 95:211–223.

Baxandall, M. 1910. "Fixation and Distraction: The Nail in Braque's Violin and Pitcher." In *Sight and Insight*, 399–415. London: Phaidon Press.

Berenson, B. 2009. "The Florentine Painters of the Renaissance: With an Index to Their Works." 1909; reprint, Ithaca, N.Y.: Cornell University Library.

Berger, J. 1993. *The Success and Failure of Picasso*. 1965; reprint, New York: Vintage International.

Berggruen, O. 2003. "Resonance and Depth in Matisse's Paper Cut-Outs." In *Henri Matisse: Drawing with Scissors—Masterpieces from the Late Years*, ed. O. Berggruen and M. Hollein, 103–127. Munich: Prestel.

Berkeley, G. 1975. "An Essay Towards a New Theory of Vision." In *Philosophical Works, Including the Works on Vision*. New York: Rowman and Littlefield. Originally published in *George Berkeley, An Essay Towards a New Theory of Vision* (Dublin: M Rhames for R Gunne, 1709).

Bhattacharya, J., and Petsche, H. 2002. "Shadows of Artistry: Cortical Synchrony During Perception and Imagery of Visual Art." *Cognitive Brain Research* 13:179–186.

Blotkamp, C. 2004. *Mondrian: The Art of Deconstruction*. 1944; reprint, London: Reaktion Books.

Bodamer, J. 1947. "Die Prosop-Agnosie." *Archiv für Psychiatrie und Nervenkrankheiten* 179:6–53.

Braun, E., and R. Rabinow. 2014. *Cubism: The Leonard A. Lauder Collection*. New York: Metropolitan Museum of Art.

Brenson, M. 1989. "Picasso and Braque, Brothers in Cubism." *New York Times*, September 22, 1989.

Breslin, J.E.B. 1993. *Mark Rothko: A Biography*. Chicago: University of Chicago Press.

Brockman, J. 1995. *The Third Culture: Beyond the Scientific Revolution*. New York: Simon and Schuster.

Buckner, R. L., and D.C. Carrol. 2007. "Self Projection and the Brain." *Trends in Cognitive Science* 11 (2): 49–57.

Cajal, S. R. 1894. "The Croonian Lecture: La fine structure des centres nerveux." *Proceedings of the Royal Society of London* 55: 444–468.

Carew, T. J., R. D. Hawkins, and E. R. Kandel. 1983. "Differential Classical Conditioning of a Defensive Withdrawal Reflex in *Aplysia californica*." *Science* 219: 397–400.

Carew, T. J., E. T. Walters, and E. R. Kandel. 1981. "Classical Conditioning in a Simple Withdrawal Reflex in *Aplysia californica.*" *Journal of Neuroscience* I: 1426–1437.

Castellucci, V. F., T. J. Carew, and E. R. Kandel. 1978. "Cellular Analysis of Long-Term Habituation of the Gill-Withdrawal Reflex in *Aplysia californica.*" *Science* 202:1306–1308.

Chace, M. R. 2010. *Picasso in the Metropolitan Museum of Art.* New York: Metropolitan Museum of Art.

Churchland, P., and T. J. Sejnowski. 1988. "Perspectives on Cognitive Neuroscience." *Science* 242:741–745.

Cohen-Solal, A. 2015. *Mark Rothko: Toward the Light in the Chapel.* New Haven and London: Yale University Press.

Da Vinci, L. 1923. *Note-Books Arranged and Rendered Into English.* Ed. R. John and J. Don Read. New York: Empire State Book Co.

Danto, A. C. 2003. *The Abuse of Beauty: Aesthetics and the Concept of Art.* Chicago and LaSalle: Open Court.

——. 2001. "Clement Greenberg." In *The Madonna of the Future,* 66–67. Berkeley: University of California Press.

——. 2001. "Willem de Kooning." In *The Madonna of the Future,* 101. Berkeley: University of California Press.

Dash, P. K., B. Hochner, and E. R. Kandel. 1990. "Injection of cAMP-Responsive Element Into the Nucleus of Aplysia Sensory Neurons Blocks Long-Term Facilitation." *Nature* 345:718–721.

DiCarlo, J. J., D. Zoccolan, and N. C. Rust. 2012. "How Does the Brain Solve Visual Object Recognition." *Neuron* 73:415–434.

Einstein, C. 1926. *Die Kunst Des 20 Jahrhunderts.* Berlin: Propyläen Verlagn.

Elbert, T., C. Pantev, C. Wienbruch, B. Rockstroh, and E. Taub. 1995. "Increased Cortical Representation of the Fingers of the Left Hand in String Players." *Science* 270:305–307.

Fairhall, S. L., and A. Ishai. 2007. "Neural Correlates of Object Indeterminacy in Art Compositions." *Consciousness and Cognition* 17:923–932.

Flam, J. 2014. "The Birth of Cubism: Braque's Early Landscapes and the 1908 Galerie Kahnweiler Exhibition." In *Cubism: The Leonard A. Lauder Collection.* New York: Metropolitan Museum of Art.

Fortune, B. B., W. W. Reaves, and D. C. Ward. 2014. *Face Value: Portraiture in the Age of Abstraction.* Washington, D.C.: Giles in Association with National Portrait Gallery, Smithsonian Institute.

Freedberg, D. 1989. *The Power of Images: Studies in the History and Theory of Response.* Chicago and London: University of Chicago Press.

Freeman, J., C. M. Ziemba, D. J. Heeger, E. P. Simoncelli, and J. A. Movshon. 2013. "A Functional and Perceptual Signature of the Second Visual Area in Primates." *Nature Reviews Neuroscience* 16 (7): 974–981.

Freese, J. L., and D. G. Amaral. 2005. "The Organization of Projections from the Amygdala to Visual Cortical Areas TE and V1 in the Macaque Monkey." *Journal of Comparative Neurology* 486 (4): 295–317.

Freud, S. 1911. "Formulation of the Two Principles of Mental Functioning. Standard Edition, Vol. 12:215–226. London: Hogarth Press, 1958).

——. 1953. "The Interpretation of Dreams." In *The Standard Edition of the Complete Psychological Works of Sigmund Freud*, ed. and trans. James Strachey, vols. IV and V. London: The Hogarth Press and the Institute for Psychoanalysis.

Freiwald, W. A. and D. Y. Tsao. 2010. "Functional Compartmentalization and Viewpoint Generalization Within the Macaque Face-Processing System." *Science* 330:845–851.

Freiwald, W. A., D. Y. Tsao, and M. S. Livingstone. 2009. "A Face Feature Space in the Macaque Temporal Lobe." *Nature Neuroscience* 12:1187–1196.

Frith, C. 2007. *Making Up the Mind: How the Brain Creates Our Mental World*. Oxford: Blackwell.

Galenson, D. W. 2009. *Conceptual Revolutions in Twentieth-Century Art*. Cambridge University Press.

Gilbert, C. 2013a. "Intermediate-level Visual Processing and Visual Primitives." In *Principles of Neural Science*, 5th ed., ed. E. R. Kandel et al., 602–620. New York: Random House.

——. 2013b. "Top-down Influences on Visual Processing." *Nature Reviews Neuroscience* 14:350–363.

Gombrich, E. H. 1960. *Art and Illusion: A Study in the Psychology of Pictorial Representation Summary*. London: Phaidon.

——. 1982. *The Image and the Eye: Further Studies in the Psychology of Pictorial Representation*. London: Phaidon.

——. 1984. "Reminiscences on Collaboration with Ernst Kris (1900–1957)." In *Tributes: Interpreters of Our Cultural Tradition*. Ithaca, N.Y.: Cornell University Press.

Gombrich, E. H., and E. Kris. 1938. "The Principles of Caricature." *British Journal of Medical Psychology* 17 (3–4): 319–342.

——. 1940. *Caricature*. Harmondsworth: Penguin.

Gopnik, A. 1983. "High and Low: Caricature, Primitivism, and the Cubist Portrait." *Art Journal* 43 (4) (winter): 371–376.

Gore, F., E. C. Schwartz, B. C. Brangers, S. Aladi, J. M. Stujenske, E. Likhtik, M. J. Russo, J. A. Gordon, C. D. Salzman, and R. Axel. 2015. "Neural Representations of Unconditioned Stimuli in Basolateral Amygdala Mediate Innate and Learned Responses." *Cell* 162:134–145.

Gray, D. 1984. "Willem de Kooning, What Do His Paintings Mean?" (thoughts based on the artist's paintings and sculpture at his Whitney Museum exhibition, December 15, 1983–February 26, 1984). http://jessieevans-dongrayart.com/essays/essay037.html.

Greenberg, C. 1948. *The Crisis of the Easel Picture.* New York: Pratt Institute.

——. 1955. "American-Type Painting." *Partisan Review* 22:179–196. Reprinted in *Art and Culture: Critical Essays,* 208–229 (Boston: Beacon, 1961).

——. 1961. *Art and Culture: Critical Essays.* Boston: : Beacon, 1961.

——. 1962. "After Abstract Expressionism." *Art International* 6:24–32.

Gregory, R. L. 1997. *Eye and Brain.* Princeton: Princeton University Press.

Gregory, R. L., and E. H. Gombrich. 1973. *Illusion in Nature and Art.* New York: Scribners.

Grill-Spector, K., and K. S. Weiner. 2014. "The Functional Architecture of the Ventral Temporal Cortex and Its Role in Categorization." *Nature Reviews Neuroscience* 15:536–548.

Grover, K. 2014. "From the Infinite to the Infinitesimal: *The Late Turner: Painting Set Free.*" *Times Literary Supplement,* October 10, 17.

Gwang-woo, K. 2014. "The Abstract of Kandinsky and Mondrian." *Beyond* 99 (December): 40–44.

Halperin, J. 2012. "Alex Katz Suggests Andy Warhol May Have Ripped Him Off a Little Bit." Blouin Art Info Blogs, April 26. http://blogs.artinfo.com/artintheair/2012/04/26/alex-katz-suggests-andy-warhol-may-have-ripped-him-off-a-little-bit/.

Hawkins, R. D., T. W. Abrams, T. J. Carew, and E. R. Kandel. 1983. "A Cellular Mechanism of Classical Conditioning in *Aplysia*: Activity-Dependent Amplification of Presynaptic Facilitation." *Science* 219:400–405.

Haxthausen, C. V. 2011. "Carl Einstein, David-Henry Kahnweiler, Cubism and the Visual Brain." NONSite.org, Issue 2. http://nonsite.org/article/carl-einstein-daniel-henry-kahnweiler-cubism-and-the-visual-brain.

Henderson, L.D. 1988. "X Rays and the Quest for Invisible Reality in the Art of Kupka, Duchamp, and the Cubists." *Art Journal* 47 (44) (sinter 1988): 323–340.

Hinojosa, Lynne J. Walhout. 2009. *The Renaissance, English Cultural Nationalism, and Modernism, 1860–1920.* New York: Palgrave Macmillan.

Hiramatsu, C., N. Goda, and H. Komatsu. 2011. "Transformation from Image-Based to Perceptual Representation of Materials Along the Human Ventral Visual Pathway. *NeuroImage* 57:482–494.

Hughes, V. "Why Are People Seeing Different Colors In That Damn Dress?" Buzz-Feed News, February 26, 2015. http://www.buzzfeed.com/virginiahughes/why-are-people-seeing-different-colors-in-that-damn-dress.

Hume, D. 1910. "An Enquiry Concerning Human Understanding." Harvard Classics Volume 37. Dayton, Ohio: P. F. Collier & Son. http://18th.eserver.org/hume-enquiry.html.

James, W. 1890. *The Principles of Psychology*. New York: Holt.

Kahneman, D., and A. Tversky. 1979. "Prospect Theory: An Analysis of Decision Under Risk." *Econometric Society* 47 (2): 263–292.

Kallir, J. 1984. *Arnold Schoenberg's Vienna*. New York: Galerie St. Etienne/Rizzoli.

Kandel, E. R. 1979. "Psychotherapy and the Single Synapse: The Impact of Psychiatric Thought on Neurobiologic Research." *New England Journal of Medicine* 301:1028–1037.

——. 2001. "The Molecular Biology of Memory Storage: A Dialogue Between Genes and Synapses." *Science* 294:1030–1038.

——. 2006. *In Search of Memory: The Emergence of a New Science of Mind*. New York: Norton.

——. 2012. *The Age of Insight: The Quest to Understand the Unconscious in Art, Mind, and Brain from Vienna 1900 to the Present*. New York: Random House.

——. 2014. "The Cubist Challenge to the Beholder's Share." In *Cubism: The Leonard A. Lauder Collection*, ed. Emily Braun and Rebecca Rabinow. New York: Metropolitan Museum of Art.

Kandel, E. R. and S. Mack. 2003. "A Parallel Between Radical Reductionism in Science and Art." Reprinted from *The Self: From Soul to Brain. Annals of the New York Academy of Science* 1001:272–294.

Kandinsky, W. 1926. *Point and Line to Plane*. New York: The Solomon R. Guggenheim Foundation.

Kandinsky, W., M. Sadleir, and F. Golffing. 1947. *Concerning the Spiritual in Art, and Painting in Particular*. 1912; reprint, New York: Wittenborn, Schultz.

Karmel, P. 1999. *Jackson Pollock: Interviews, Articles, and Reviews*. New York: Museum of Modern Art.

———. 2002. *Jackson Pollock: Interviews, Articles, and Reviews.* Excerpt, "My Painting," *Possibilities (New York)* I (Winter 1947–48): 78–83. Copyright The Pollock-Krasner Foundation, Inc.

Karmel, P., and K. Varnedoe. 2000. Jackson Pollock: New Approaches. New York: Abrams.

Kawabata, H., and S. Zeki. 2004. "Neural Correlates of Beauty." *Journal of Neurophysiology* 91:1699–1705.

Kemp, R., G. Pike, P. White, and A. Musselman. 1996. "Perception and Recognition of Normal and Negative Faces: The Role of Shape from Shading and Pigmentation Cues." *Perception* 25:37–52.

Kemp, W. 2000. Introduction to *The Group Portraiture of Holland*, by Alois Riegl. Trans. E. M. Kain and D. Britt. 1902; reprint, Los Angeles: Getty Center for the History of Art and Humanities.

Kobatake, E., and K. Tanaka. 1994. "Neuronal Selectivities to Complex Object Features in the Ventral Visual Pathway of the Macaque Cerebral Cortex." *Journal of Neurophysiology* 71:856–867.

Kris, E., and A. Kaplan. 1952. "Aesthetic Ambiguity." In *Psychoanalytic Explorations in Art*, ed. E. Kris, 243–264. 1948; reprint, New York: International Universities Press.

Lacey, S., and K. Sathian. 2012. "Representation of Object Form in Vision and Touch." In *The Neural Basis of Multisensory Processes*, ed. M. M. Murray and M. T. Wallace, chapter 10. Boca Raton, Fla.: CRC Press.

Lafer-Sousa, R., and B. R. Conway. 2013. "Parallel, Multi-Stage Processing of Colors, Faces and Shapes in the Macaque Inferior Temporal Cortex." *Nature Reviews Neuroscience* 16 (12): 1870–1878.

Lipsey, R. 1988. An Art of Our Own: The Spiritual in Twentieth-Century Art. Boston and Shaftesbury: Shambhala.

Livingstone, M. 2002. *Vision and Art: The Biology of Seeing.* New York: Abrams.

Livingstone, M., and D. Hubel. 1988. "Segregation of Form, Color, Movement, and Depth: Anatomy, Physiology, and Perception." *Science* 240 (4853) (May 6, 1988): 740–749.

Loran, E. 2006. *Cezanne's Composition: Analysis of His Form with Diagrams and Photographs of His Motifs.* Berkeley: University of California Press.

Macknik, S. L., and S. Martinez-Conde. 2015. "How 'The Dress' Became an Illusion Unlike Any Other." *Scientific American MIND* (July/August 2015): 19–21.

Marr, D. 1982. *Vision: A Computational Investigation Into the Human Representation and Processing of Visual Information.* San Francisco: W. H. Freeman.

Mayberg, H. S. 2014. "Neuroimaging and Psychiatry: The Long Road from Bench to Bedside." *The Hastings Center Report: Special Issue* 44(S2): S31–S36.

Mechelli, A., C. J. Price, K. J. Friston, A. Ishai. 2004. "Where Bottom-up Meets Top-Down: Neuronal Interactions During Perception and Imagery." *Cerebral Cortex* 14:1256–1265.

Merzenich, M. M., E. G. Recanzone, W. M. Jenkins, T. T. Allard, and R. J. Nudo. 1988. "Cortical Representational Plasticity." In *Neurobiology of Neocortex*, ed. P. Rakic and W. Singer, 41–67. New York: Wiley.

Meulders, M. 2012. *Helmholtz: From Enlightenment to Neuroscience.* Trans. Laurence Garey. Cambridge, Mass.: MIT Press.

Mileaf, J., C. Poggi, M. Witkovsky, J. Brodie, and S. Boxer. 2012. *Shock of the News.* London: Lund Humphries.

Miller, A. J. 2001. *Einstein, Picasso: Space, Time, and the Beauty That Causes Havoc.* New York: Basic Books.

Miyashita, Y., M. Kameyam, I. Hasegawa, and T. Fukushima. 1998. "Consolidation of Visual Associative Long-Term Memory in the Temporal Cortex of Primates." *Neurobiology of Learning and Memory* 70:197–211.

Mondrian, P. 1914. "Letter to Dutch Art Critic H. Bremmer." Mentalfloss.com article 66842.

Naifeh, S., and G. Smith. 1989. *Jackson Pollock: An American Saga.* New York: Clarkson N. Potter.

Newman, B. 1948. "The Sublime Is Now." *Tiger's Eye* 1 (6) (December): 51–53.

Ohayon, S., W. A. Freiwald, and D. Y. Tsao. 2012. "What Makes a Cell Face Selective? The Importance of Contrast." *Neuron* 74:567–581.

Pessoa, L. 2010. "Emergent Processes in Cognitive-Emotional Interactions." *Dialogues in Clinical Neuroscience* 12 (4): 433–448.

Piaget, J. 1969. *The Mechanisms of Perception.* Trans. M. Cook. New York: Basic Books.

Pierce, R. 2002. *Morris Louis: The Life and Art of One of America's Greatest Twentieth-Century Abstract Artists.* Rockville, Md.: Robert Pierce Productions.

Potter, J. 1985. *To a Violent Grave: An Oral Biography of Jackson Pollock.* New York: Pushcart Press.

Princenthal, N. 2015. *Agnes Martin: Her Life and Art.* New York: Thames & Hudson.

Purves, D., and R. B. Lotto. 2010. *Why We See What We Do Redux: A Wholly Empirical Theory of Vision.* Sunderland, Mass.: Sinauer Associates.

Quinn, P. C., P. D. Eimas, and S. L. Rosenkrantz. 1993. "Evidence for Repre-sentations of Perceptually Similar Natural Categories by 3-Month-Old and 4-Month-Old Infants." *Perception* 22:463–475.

Raichle, M. E., A. M. MacLeod, A. Z. Snyder, D. A. Gusnard, and G. L. Shul-man. 2001. "A Default Mode of Brain Function. *Proceedings of the National Academy of Science* 98 (2): 676–682.

Ramachandran, V. S. 2011. *The Tell-Tale Brain: A Neuroscientist's Quest for What Makes Us Human.* New York: Norton.

Ramachandran, V. S., and W. Hirstein. 1999. "The Science of Art: A Neu-ro-Logical Theory of Aesthetic Experience." *Journal of Consciousness Stud-ies* 6:15–51.

Rewald, J. 1973. *The History of Impressionism.* 4th rev. ed. New York: Museum of Modern Art.

Riegl, A. 2000. The Group Portraiture of Holland. Trans. E. M. Kain and D. Britt. 1902; reprint, Los Angeles: Getty Center for the History of Art and Humanities.

Rosenblum, Robert. 1961. "The Abstract Sublime." *ARTnews* 59 (10): 38–41, 56, 58.

Rosenberg, Harold. 1952. "The American Action Painters." *ARTnews* 51 (8) (December), 22.

Ross, C. 1991. *Abstract Expressionism: Creators and Critics: An Anthology.* New York: Abrams.

Rubin, W. 1989. *Picasso and Braque: Pioneering Cubism.* New York: Museum of Modern Art.

Sacks, O. 1985. *The Man Who Mistook His Wife for a Hat.* New York: Summit Books.

Sandback, F. 1982. *74 Front Street: The Fred Sandback Museum, Winchendon, Massachusetts.* New York: Dia Art Foundation.

——. 1991. *Fred Sandback: Sculpture.* Yale University Art Gallery, New Haven, Conn., in association with Contemporary Arts Museum, Houston, Texas, 1991. Texts by Suzanne Delehanty, Richard S. Field, Sasha M. Newman, and Phyllis Tuchman.

——. 1995. Introduction to *Long-Term View* (installation). Dia Beacon. http://www.diaart.org/exhibitions/introduction/95.

——. 1997. Interview by Joan Simon. Bregenz: Kunstverein.

Sathian, K., S. Lacey, R. Stilla, G. O. Gibson, G. Deshpande, X. Hu, S. Laconte, and C. Glielmi. 2011. "Dual Pathways for Haptic and Visual Perception of Spatial and Texture Information." *Neuroimage* 57:462–475.

Schjeldahl, P. 2011. "Shifting Picture: A de Kooning Retrospective." *The New Yorker*, September 26.

Schrödinger, E. 1944. *What Is Life?* Cambridge: Cambridge University Press.

Shlain, L. 1993. *Art and Physics: Parallel Visions in Space, Time, and Light*. New York: HarperCollins.

Sinha, P. 2002. "Identifying Perceptually Significant Features for Recognizing Faces." *SPIE Proceedings Vol. 4662: Human Vision and Electronic Imaging VII*. San Jose, California.

Smart, A. 2014. "Why Are Monet's Water Lilies So Popular?" *The Telegraph*, October 18.

Smith, R. 2015. "Mondrian's Paintings and Their Pulsating Intricacy." *New York Times*, August 20, C23.

Snow, C. P. 1961. *Two Cultures and the Scientific Revolution: Rede Lecture 1959*. Cambridge: Cambridge University Press.

——. 1963. *The Two Cultures and a Second Look*. Cambridge: Cambridge University Press.

Solomon, D. 1994. "A Critic Turns 90; Meyer Schapiro." *New York Times Magazine*, August 14.

Solso, R. L. 2003. *The Psychology of Art and the Evolution of the Conscious Brain*. Cambridge, Mass.: MIT Press.

Spies, W. 2011. *The Eye and the World: Collected Writings on Art and Literature*. Vol. 6: Surrealism and Its Age. New York: Abrams.

——. 2011. *The Eye and the World: Collected Writings on Art and Literature*. Vol. 8: Between Action Painting and Pop Art. New York: Abrams.

——. 2011. *The Eye and the World: Collected Writings on Art and Literature*. Vol. 9: From Pop Art to the Present. New York: Abrams.

Squire, L. and E. R. Kandel. 2000. *Memory: From Mind to Molecules*. New York: Scientific American Books.

Starr, G. 2014. "Neuroaesthetics: Art." In *The Oxford Encyclopedia of Aesthetics, Second Edition*, ed. Michael Kelly, 4:487–491. New York: Oxford University Press.

Stevens, M., and A. Swan. 2005. *D5e Kooning: An American Master*. New York: Random House.

Strand, Mart. 1984. *Art of the Real: Nine Contemporary Figurative Painters*. New York: Clarkson N. Potter.

Tanaka, K., H. Saito, Y. Fukada, and M. Moriya. 1991. "Coding Visual Images of Objects in the Inferotemporal Cortex of the Macaque Monkey." *Journal of Neurophysiology* 66 (1): 170–189.

Taylor, R. P., B. Spehar, P. Van Donkelaar, and C. M. Hagerhall. 2011. "Perceptual and physiological responses to Jackson Pollock's Fractals." *Frontiers in Human Neuroscience* 5:60.

Tomkins, C. 2003. "Flying Into the Light: How James Turrell Turned a Crater Into His Canvas." *The New Yorker* 78 (42) (January 13).

Tovee, M. J., E. T. Rolls, and V. S. Ramachandran. 1996. "Rapid Visual Learning in Neurons of the Primate Temporal Visual Cortex." *Neuroreport* 7:2757–2760.

Treisman, A. 1986. "Features and Objects in Visual Processing." *Scientific American* 255 (5): 114–225.

Trope, Y., and N. Liberman. 2010. "Construal-Level Theory of Psychological Distance." *Psychological Review* 117 (2): 440–463.

Tsao, D. Y., N. Schweers, S. Moeller, and W. A. Freiwald. 2008. "Patches of Face-Selective Cortex in the Macaque Frontal Lobe." *Nature Reviews Neuroscience* 11:877–879.

Tully, T., T. Preat, C. Boynton, and M. Delvecchio. 1994. "Genetic Dissection of Consolidated Memory in *Drosophila melanogaster*." *Cell* 79:35–47.

Tversky, A., and D. Kahneman. 1992. "Advances in Prospect Theory: Cumulative Representation of Uncertainty." *Journal of Risk and Uncertainty* 5:297–323.

Ungerleider, L. G., J. Doyon, and A. Karni. 2002. "Imaging Brain Plasticity During Motor Skill Learning." *Neurobiology of Learning and Memory* 78:553–564.

Upright, D. 1985. *Morris Louis: The Complete Paintings*. New York: Abrams.

Varnedoe, K. 1999. "Open-ended Conclusions About Jackson Pollock." In *Jackson Pollock: New Approaches*, ed. Kirk Varnedoe and Pepe Karmel, 245. New York: The Museum of Modern Art.

Warhol, A. and P. Hackett. 1980. *Popism: The Warhol Sixties*. New York: Harcourt Brace Jovanovich.

Watson, J. D. 1968. *The Double Helix: A Personal Account of the Discovery of the Structure of DNA*. New York: Atheneum.

Wilson, E. O. 1977. "Biology and the Social Sciences." *Daedalus* 2:127–140.

Witzel, C. 2015. "The Dress: Why Do Different Observers See Extremely Different Colors in the Photo?" http://lpp.psycho.univ-paris5.fr/feel/?page_id=929.

Wurtz, R. H., and E. R. Kandel. 2000. "Perception of Motion, Depth and Form." In *Principles of Neural Science IV*. [[[City:]]] McGraw-Hill.

Vessel, E. A., G. G. Starr, and N. Rubin. 2012. "The Brain on Art: Intense Aesthetic Experience Activates the Default Mode Network." *Frontiers in Human Neuroscience* 6:66.

Yin, J. C. P., J. S. Wallach, M. Delvecchio, E. L. Wilder, H. Zhuo, W. G. Quinn, and T. Tully. 1994. "Induction of a Dominant Negative CREB Transgene Specifically Blocks Long-Term Memory in *Drosophila*." *Cell* 79:49–58.

Zeki, S. 1998. "Art and Brain." *Daedalus* 127:71–105.

——. 1999. *Inner Vision: An Exploration of Art and the Brain*. Oxford: Oxford University Press.

——. 1999. "Art and the Brain." *Journal of Consciousness Studies* 6:76–96.

Zilczer, J. 2014. *A Way of Living: The Art of Willem de Kooning*. New York: Phaidon Press.

ILLUSTRATION CREDITS

INTRODUCTION

i.1 © Corbis

CHAPTER 1

1.3 University Archives, Rare Book & Manuscript Library, Columbia University in the City of New York

CHAPTER 2

2.2 Image courtesy of Images From the History of Medicine

2.3 © The Associated Press

CHAPTER 3

3.2 a. Modified from Rose Lafer Sousa. b. *Self-Portrait at the Age of 63*, 1669 (oil on canvas) by Rembrandt Harnensz van Rijn (1606–1669). c. Courtesy of Charles Stevens

3.3 Adapted from Kobatake and Tanaka, 1994

CHAPTER 4

4.1 *Left*: Photograph courtesy Thomas Teyke. *Right*: Tate, London / Art Resource, NY. © 2016 Succession H. Matisse / Artist's Right Society (ARS), New York

4.7 Adapted from Elbert et al. 1995

CHAPTER 5

5.1 Private collection © Look and Learn / Elgar Collection / Bridgeman Images

5.2 National Gallery, London, UK / Bridgeman Images

5.3 © Tate, London 2015

5.4 Musee Marmottan Monet, Paris, France / Bridgeman Images

5.5 Image courtesy of Awesome Art

5.6 Musee Marmottan Monet, Paris, France / Bridgeman Images

5.7 Denver Art Museum Collection: Funds from Helen Dill bequest, 1935.14. Photo courtesy Denver Art Museum

5.8 Staatsgalerie Moderner Kunst, Munich, Germany / Bridgeman Images. © Artists Rights Society (ARS), New York

5.9 HIP / Art Resource, NY. © Artists Rights Society (ARS), New York

5.10 Image courtesy of The Arnold Schoenberg Center, Vienna, Austria. © 2016 Belmont Music Publisher, Los Angeles / ARS, New York / Bildrecht, Vienna

5.11 Image courtesy of The Arnold Schoenberg Center, Vienna, Austria. © 2016 Belmont Music Publisher, Los Angeles / ARS, New York / Bildrecht, Vienna

5.12 Image courtesy of The Arnold Schoenberg Center, Vienna, Austria. © 2016 Belmont Music Publisher, Los Angeles / ARS, New York / Bildrecht, Vienna

5.13 Image courtesy of The Arnold Schoenberg Center, Vienna, Austria. © 2016 Belmont Music Publisher, Los Angeles / ARS, New York / Bildrecht, Vienna

CHAPTER 6

6.1 Image courtesy of De Stijl Archives / The Mondrian Edition Project

6.2 Private collection. Image courtesy of The Mondrian/Holtzman Trust

6.3 Gemeentemuseum, Holland. © Mondrian/Holtzman Trust

6.4 Munson-Williams-Proctor Arts Institute / Art Resource, NY

6.5 Kroller-Muller Museum, Holland. © 2016 Mondrian/Holtzman Trust

6.6 Adapted from Hubel and Wiesel 1968

6.7 Private collection. © Mondrian/Holtzman Trust

6.8 Museum of Modern Art, New York. Image courtesy of The Mondrian/ Holtzman Trust

CHAPTER 7

7.1 Tony Vaccaro / Archive Photos / Getty Images

7.2 The Philadelphia Museum of Art / Art Resource, NY. © 2016 The Willem de Kooning Foundation / Artists Rights Society (ARS), New York

7.3 Frederick R. Weisman Art Foundation, Los Angeles, CA, USA / Bridgeman Images. © 2016 The Willem de Kooning Foundation / Artists Rights Society (ARS), New York

7.4 Art Institute of Chicago, IL, USA / De Agostini Picture Library / M. Carrieri / Bridgeman Images. © 2016 The Willem de Kooning Foundation / Artists Rights Society (ARS), New York

7.5 Museum of Modern Art, New York, USA / Bridgeman Images. © 2016 The Willem de Kooning Foundation / Artists Rights Society (ARS), New York

7.6 Thilo Parg / Wikimedia Commons. CC-BY-SA 3.0

7.7 © Belvedere, Vienna

7.8 Based on data from Anderson 2012

7.9 Based on data from Anderson 2012

7.10 Purchased 1985 with the assistance of the Queensland Art Gallery Foundation. Collection: Queensland Art Gallery, Brisbane. © 2016 The Willem de Kooning Foundation / Artists Rights Society (ARS), New York

7.11 Museum Frieder Burda, Baden-Baden. © 2016 The Willem de Kooning Foundation / Artists Rights Society (ARS), New York

7.12 Tony Vaccaro / Archive Photos / Getty Images

7.13 Smithsonian American Art Museum, Washington, DC / Art Resource, NY. © The Pollock-Krasner Foundation / Artists Rights Society (ARS), New York

7.14 Museum Frieder Burda, Baden-Baden. © The Pollock-Krasner Foundation / Artists Rights Society (ARS), New York

7.15 Private collection / © Leemage / Bridgeman Images. © The Pol-
lock-Krasner Foundation / Artists Rights Society (ARS), New York

7.16 bpk, Berlin / Kunstsammlung Nordrhein-Westfalen / Walter Klein /
Art Resource, NY. © The Pollock-Krasner Foundation / Artists Rights
Society (ARS), New York

CHAPTER 8

8.1 Adapted from Albright 2015

8.2 Adapted from Albright 2013

8.3 Adapted from Albright 2012

8.4 Adapted from Albright 2012

8.5 The Philadelphia Museum of Art / Art Resource, NY. © 2016 The Wil-
lem de Kooning Foundation / Artists Rights Society (ARS), New York

8.6 Art Institute of Chicago, IL, USA / De Agostini Picture Library / M.
Carrieri / Bridgeman Images. © 2016 The Willem de Kooning Founda-
tion / Artists Rights Society (ARS), New York

8.7 Smithsonian American Art Museum, Washington, DC / Art Resource,
NY. © The Pollock-Krasner Foundation / Artist's Rights Society (ARS),
New York

8.8 bpk, Berlin / Kunstsammlung Nordrhein-Westfalen / Walter Klein /
Art Resource, NY. © The Pollock-Krasner Foundation / Artist's Rights
Society (ARS), New York

CHAPTER 9

9.1 Photo © PVDE/Bridgeman Images. © 1998 Kate Rothko Prizel &
Christopher Rothko / Artists Rights Society (ARS), New York

9.2 Photo credit: Art Resource, NY. © 1998 Kate Rothko Prizel & Christo-
pher Rothko / Artists Rights Society (ARS), New York

9.3 © 1998 Kate Rothko Prizel & Christopher Rothko / Artists Rights
Society (ARS), New York

9.4 © 1998 Kate Rothko Prizel & Christopher Rothko / Artists Rights
Society (ARS), New York

9.5 Private collection. Photo © Christie's Images / Bridgeman Images.
© 1998 Kate Rothko Prizel & Christopher Rothko / Artists Rights
Society (ARS), New York

9.6 Image courtesy of The National Gallery of Art, Washington, DC. © 1998 Kate Rothko Prizel & Christopher Rothko / Artists Rights Society (ARS), New York

9.7 Unidentified photographer. Miscellaneous photographs collection. Archives of American Art, Smithsonian Institution

9.8 Photograph © 2016 Museum of Fine Arts, Boston. Grant Walker Fund, 1984.762. © 2016 Maryland Institute College of Art (MICA). Rights administered by Artists Rights Society (ARS), New York. All rights reserved.

9.9 Photo courtesy of Charles Bernstein. © 2016 Maryland Institute College of Art (MICA). Rights administered by Artists Rights Society (ARS), New York. All rights reserved.

9.10 Private collection / Bridgeman Images. © 2016 Maryland Institute College of Art (MICA). Rights administered by Artists Rights Society (ARS), New York. All rights reserved.

9.11 Private collection / Bridgeman Images. © 2016 Maryland Institute College of Art (MICA). Rights administered by Artists Rights Society (ARS), New York. All rights reserved.

9.12 Saint Louis Art Museum, Missouri, USA. Funds given by the Schoenberg Foundation, Inc. / Bridgeman Images. © 2016 Maryland Institute College of Art (MICA). Rights administered by Artists Rights Society (ARS), New York. All rights reserved.

9.13 The Philadelphia Museum of Art / Art Resource, NY. © 2016 Maryland Institute College of Art (MICA). Rights administered by Artists Rights Society (ARS), New York. All rights reserved.

9.14 Image courtesy of Kunsthaus Zurich. © 2016 Maryland Institute College of Art (MICA). Rights administered by Artists Rights Society (ARS), New York. All rights reserved.

9.15 Private collection / Photo © Christie's Images / Bridgeman Images. © 2016 Maryland Institute College of Art (MICA). Rights administered by Artists Rights Society (ARS), New York. All rights reserved.

CHAPTER 10

10.1 From Kandel 2012

10.3 From Kandel, Schwartz, and Jessell 2000, p. 573. Images courtesy of K. R. Gegenfurtner

CHAPTER 11

11.1 Fred W. McDarrah / Premium Archive / Getty Images

11.2 Photo: Billy Jim, New York. Courtesy Dia Art Foundation, New York. © Stephen Flavin / Artists Rights Society (ARS), New York

11.3 Photo: Bill Jacobson, New York. Courtesy Dia Art Foundation, New York. © Stephen Flavin / Artists Rights Society (ARS), New York

11.4 Image courtesy of The National Gallery of Art, Washington, DC. © Stephen Flavin / Artists Rights Society (ARS), New York

11.5 Photo by Florian Holzherr. Copyright James Turrell

11.6 Solomon R. Guggenheim Museum, New York. Panza Collection, Gift, 1992. 92.4175. Installation view: Singular Forms (sometimes repeated), Solomon R. Guggenheim Museum, New York, March 5–May 19, 2004. Photograph by David Heald © The Solomon R. Guggenheim Foundation, New York. Copyright James Turrell

11.7 Photo by Florian Holzherr. Copyright James Turrell

CHAPTER 12

12.1 Photo copyright 1996 Vivien Bittencourt. Art © Alex Katz/Licensed by VAGA, New York, NY

12.2 Albertina, Wien. www.albertina.at. Art © Alex Katz / Licensed by VAGA, New York, NY

12.3 Albertina, Wien. www.albertina.at. Art © Alex Katz / Licensed by VAGA, New York, NY

12.4 © DACS London / VAGA, New York, 2016. Art © Alex Katz / Licensed by VAGA, New York, NY

12.5 Private collection. Art © Alex Katz / Licensed by VAGA, New York, NY

12.6 Fred W. McDarrah / Getty Images

12.7 Digital Image © The Museum of Modern Art / Licensed by SCALA / Art Resource, NY. Marilyn Monroe: Rights of Publicity and Persona Rights: The Estate of Marilyn Monroe LLC. © 2016 The Andy Warhol Foundation for the Visual Arts, Inc. / Artists Rights Society (ARS), New York

12.8 Collection of the Andy Warhol Museum, Pittsburgh. © 2016 The Andy Warhol Foundation for the Visual Arts, Inc. / Artists Rights Society (ARS), New York

12.9 bpk, Berlin / Spregnal Museum / Michael Herling, Aline Gwose / Art Resource, NY. © 2016 The Andy Warhol Foundation for the Visual Arts, Inc. / Artists Rights Society (ARS), New York

12.10 Photograph by Gianfranco Gorgoni. Image courtesy Pace Gallery. © Chuck Close

12.11 Image courtesy of Pace Gallery. © Chuck Close

12.12 Image courtesy of Pace Gallery. © Chuck Close

CHAPTER 13

13.1 Photo: Thomas Cugini, Zurich. © 2016 Fred Sandback Archive

13.2 Courtesy David Zwirner, New York/London. © 2016 Fred Sandback Archive

INDEX

Italic page numbers refer to figures in the text.

Aplysia (sea snail), *48–51*, 48–55, 148
art criticism, 10–14. *See also* Greenberg,
Clement; Rosenberg, Harold;
Schapiro, Meyer
art, responses to. *See* perception
art–science connection, 3–7, 187–189.
See also brain; perception;
reductionism; vision
associations, learned, 22, 45, 50, 52–54,
65, 110–122, *113*, 141
attention, 22–23, 29, 35
Aubry, Eugene, 128
Avery, Oswald, 42
Axel, Richard, 147

Barnstone, Howard, 128
Barr, Alfred, 193n2
Baudelaire, Charles, 71
Bazille, Frédéric, 67
"beholder's share," 17–20, 25–39,
109, 115, 178–185. *See also*
associations, learned; Gombrich,
Ernst; Kris, Ernst; perception;
Riegl, Alois
Benton, Thomas Hart, 101
Berenson, Bernard, 100–101
Berggruen, Olivier, 48
Berkeley, George, 21, 44
Bodamer, Joachim, 30, 32
bottom-up processing, 21–22, 25–26, 29,
33, 109, 114
brain, 3–4, 6–7, 17–39, 187–189
and aggression and sexuality, 96, *97*
Aplysia studies, *48–51*, 48–55, 148
brain damage, 30, 143
and central nervous system, 35–37
and color processing, 143–154, *147*
cortical map, 55, *56*
default network, 183–185
and learning and memory, 41–58,
111–114, *113*

modification of the functional
architecture, 55–57
monkey studies, *31*, 32, 34, 55, 112,
116
and pattern recognition, 107–108,
144
preconscious mental processes,
184–185
processing and perception of abstract
images, 109–122, 178–185 (*see also*
perception)
and reductionism, 6, 41–43
response to lines, 80–83
separate processing of color and form,
143, 146
what and *where* pathways, 26–29,
27, 38
See also bottom-up processing;
emotion; perception; top-down
processing; vision; *specific brain
regions, such as* inferior temporal
cortex
Brando, Marlon, 168
Braques, Georges, 73, 77, 128, 143
brightness, *111, 149*
Broadway Boogie Woogie (Mondrian), 83,
85, 91
Brockman, John, 194n2
Buckner, R. L., 184

Calais Pier (Turner), 62, 63, *64*
Carroll, D. C., 184
central nervous system, 35–37, 43
cerebellum, 46
cerebral cortex, 26–30
Cézanne, Paul, 13, 67–68, 73, 77, 83
Churchland, Patricia, 35
classical conditioning, 45, 52–54
Close, Chuck, 14, 163, 164, 171–174,
172–174
Coates, Robert, 193n2

striatum, 46
Stripes series (Louis), 137–138, *139*, *140*
structural organization of the nervous
 system, 35, *36*
superior parietal cortex, 114
Surrealism, 87, 91, 188
Swan, Annalyn, 90–91

Tatlin, Vladimir, 158
Taylor, Elizabeth, 168, 171
The Tea Cup (Pollock), 102, *104*
temporal lobe, 28, 30, *31*, 46, 57, 112–114,
 113, 116, 146–148, 183
texture, 37, 98, 100–101, 108
Thinking (Schoenberg), 74, *76*
Third Element (Louis), *140*
Thorndike, Edward, 45
Tight End (Turrell), 161, *161*
Tomkins, Calvin, 159
top-down processing, 21–23, 29–30
 and color, 144, 150–154
 defined/described, 22–23
 and face processing, 33
 and hippocampus, 28
 and learning and memory, 43–58
 and perception of abstract images, 22,
 23, 109–115, 178–181
 and responses to art, 22, 23, 57–58,
 114–115, 122
 and suppression of irrelevant
 information, 23
touch, 37–39, 100–101
Tree (Mondrian), *80*
Treisman, Anne, 29
Tsao, Doris, 32, 34–35
Turner, J. M. W., 6, 61–65, *62*, *64–65*, 69,
 115, 163
Turrell, James, 159–161, *159–161*, 179
Tversky, A., 107
Two Trees on Mary Street . . . Amen!
 (de Kooning), 98, *99*

Unfurled series (Louis), 136–138,
 137–138
Ungerleider, Leslie, 55
Untitled (Rothko), *125*
*Untitled (Sculptural Study,
 Seven-part Right-angled
 Triangular Construction)*
 (Sandback), *181*
Untitled (Two Women) (Louis), *133*
Untitled X (de Kooning), 98–99, *100*

van Gogh, Vincent, 23, 77, 108
Varnedoe, Kirk, 107
Veils series (Louis), 134–136, *135–136*
Venus of Hohle Fels, *94*, 94
Vessel, Edward, 184
visible spectrum, 26–27, *145*. *See also*
 light, and vision
vision, 25–39, *152*
 and attention, 29
 and bottom-up processing, 21–22,
 25–26, 29, 109
 color vision, 144–154, *145*, *147*, *149*
 computer models, 34
 distinction between sensation and
 perception, 111, 114
 and emotion, 37–39
 face processing, 28, 29–35, 57, 109,
 112
 ganzfeld effect, 160
 inverse optics problem, 20–23, 109
 and learning and memory, 45
 levels of processing, 22, 28–29, 83
 mechanics of, 20
 and object recognition, 22, 27–30,
 148, *149*
 organization of the visual system,
 26–30, *27*
 and perception of abstract images, 22,
 23, 109–115, 178–185
 rods and cones, 26–27, 144, 151